# THEN & NOW
# CHESTER

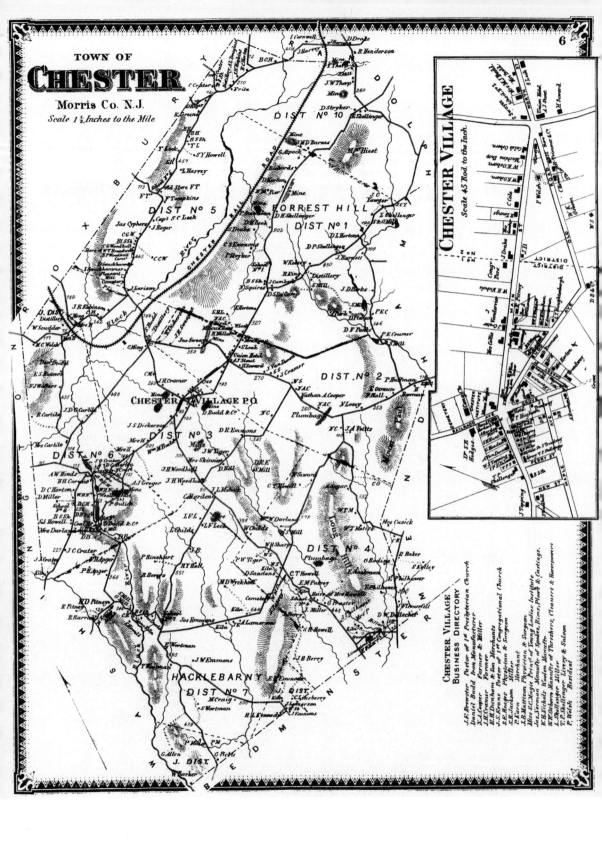

# THEN & NOW
# CHESTER

Joan S. Case

ARCADIA

Copyright © 2005 by Joan S. Case
ISBN 0-7385-3872-8

Published by Arcadia Publishing
Charleston SC, Chicago IL, Portsmouth NH, San Francisco CA

Printed in Great Britain

Library of Congress Catalog Card Number: 2005926273

For all general information contact Arcadia Publishing at:
Telephone 843-853-2070
Fax 843-853-0044
E-mail sales@arcadiapublishing.com
For customer service and orders:
Toll-Free 1-888-313-2665

Visit us on the Internet at http://www.arcadiapublishing.com

*I would like to dedicate this book to Carmen Smith, whose love and devotion to the history of Chester has inspired many, including myself.*

# CONTENTS

# ACKNOWLEDGMENTS

I would like to thank each and every person who gave of their time and effort to help make this book possible. Carmen Smith, Len Taylor, and the Board of the Chester Historical Society helped answer my many questions and provided many of the photographs located throughout this book. A special thank you goes out to Frances Greenidge and Edwin Collis, who, many years ago, took the time and effort to search out and record much of Chester's history for the residents of Chester and other interested parties. I would like to thank Bob Lyons and his staff at Chester Camera, who always came through with the photograph processing jobs I brought them. Lynn Laffey, Mark Texel, and Ivins Smith from the Morris County Park Commission were a great help with information and photographs from the four sites that the commission owns in Chester. And here are some special people who helped in large and small ways in the completion of this book: Joyce and John Wyckoff, John Apgar, Willard Apgar, Ken Caro, Margaret Ardin, Eunice Lee, Clara Ammerman, Susan LeLoup, and William Asdal.

# INTRODUCTION

The town of Chester is a small community located in the rolling hills of Morris County, New Jersey, and stills retains much of the rich historic heritage that is obvious in the architecture of the remaining older structures throughout the town.

In the early 1700s, Lenni-Lenapi Indians inhabited Chester, originally known as Roxbury and also Black River. Chester was first surveyed and mapped in 1713 by proprietors for the provinces of East and West Jersey. The Lawrence line, dividing East and West Jersey in colonial times, went directly through Chester. The first permanent settlers arrived in the 1730s and began farming. Later in the 1700s, their activities centered on inn-keeping, mining, and milling, along with simple agricultural life. In 1799, Chester Township became incorporated and broke away from Roxbury. Then in 1930, the village center broke away from the township due to a water dispute and became Chester Borough.

During the early 1800s, Chester was a stagecoach stop where travelers sought overnight accommodations at the different inns and hotels along the highly traveled roads through town. These roads influenced the growth of early Chester. Products from Pennsylvania, such as wheat, grains, vegetables, and sundries, passed through on the way to New York. Chester also had products to send to the New York market, such as their famous "Jersey Lighting" applejack and fine furniture, notably, James Topping's clock cases and bureaus.

Chester's apples and peaches were of the highest quality, and these crops were a financial success. Many distilleries opened, and ease in transporting the crops became a necessity. There were forges, furnaces, a brickyard, and gristmills in every corner of the township.

The Civil War changed Chester from a farming community to a small industrial town. Chester had a boom, and the iron mines were the sole cause of considerable prosperity. There were at least 35 working mines in and around the town. During the period from the late 1860s to the late 1880s, several hundred thousand tons of iron ore were taken from these mines. A railroad was built for the ore to be shipped, and two different railroad stations were built. The Central Railroad built one in town, and the Delaware, Lackawanna and Western Railroad built the second one about a mile north of town. Iron was discovered in the Mesabi Desert in Minnesota, which was the demise for the high iron life of Chester. Those who knew only mining were hard-pressed. Those who had retained their farms began again to raise crops. Their apples, peaches, garden produce, and grains helped to keep the economy alive. Chester became quiet and relaxed, and existed as a small farming community with beautiful homes, but with little money to support itself.

The land mass is just over 29 square miles, with a population estimated to be approximately 7,250, according to the 2000 census. Today, there are approximately 2,100 homes in Chester Township. The land use is primarily residential and agricultural.

The borough enjoys a flourishing commercial area, while most of the land area in the 1.45 square miles of the community is devoted to single-family housing. The township completely surrounds the more densely developed Chester Borough, which lies at the geographic center of the township. The borough serves as the town center for the area and has several shopping centers. Of the 29.3 square miles (18,497 acres) that comprise the township, less than two percent is zoned for commercial or industrial use. Over 40 percent of the township is currently devoted to some form of permanent open space,

which includes both parkland and preserved farmland. As of January 2005, the township has 722 acres of preserved farmland on 10 farms.

The earlier roads were mere bridle paths widened to accommodate crude farm wagons that had wheels made of a slice of a solid tree trunk. By 1800, passengers were requesting more comforts. The Washington Turnpike, which ran from Jersey City to Easton, was chartered March 3, 1806, and Chester's Jared Haines was a director. In 1810, Zephaniah Drake, in addition to being the innkeeper, was proprietor of the first line of stagecoaches on the turnpike. They were painted scarlet with gold trimmings and were drawn by four horses.

*Chapter 1*

# SCENES AROUND TOWN

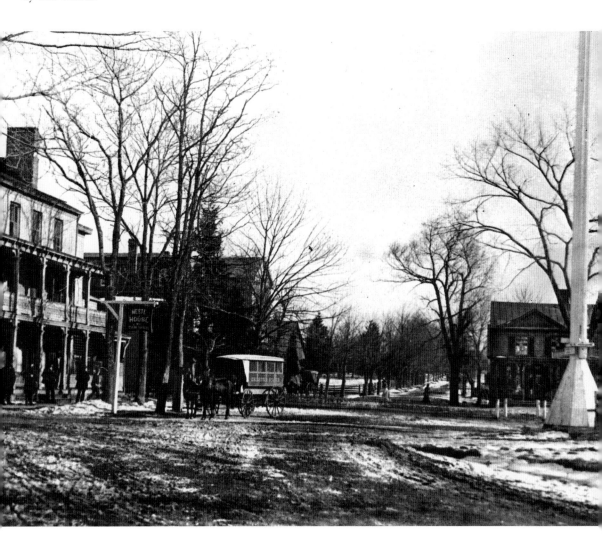

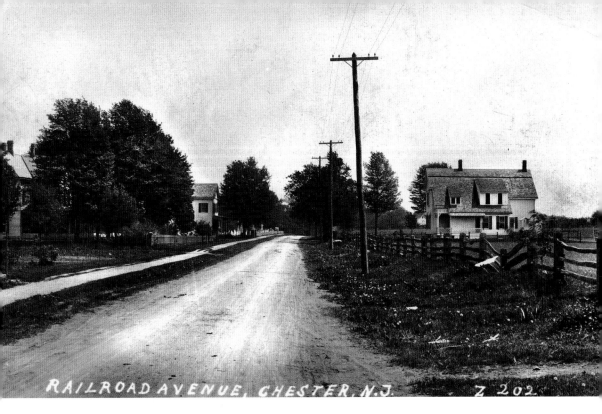

RAILROAD AVENUE, CHESTER, N.J.    Z 202

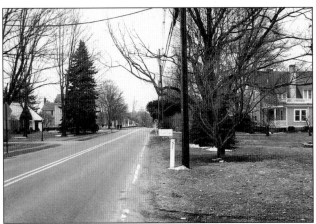

Before 1740, two great roads intersected in what was to become known as Chester. One was eventually called the Washington Turnpike and went from Morristown to Pennsylvania, and the other was called the Landing Road and led from Brunswick Landing to Sussex County. Shown here is the Landing Road, also known as Railroad Avenue, shooting towards the center of town. The Chester Stage Coach ran between the village and the Muskrat Depot (a Delaware, Lackawanna and Western Railroad station) until 1920.

In the 1890s, Edmund Sturzenegger of New York City purchased this property near the Muskrat Depot at the corner of what are now known as Hillside and Oakdale Roads from Isabella (Ming) Skellenger. He purchased the property not only for a family home, but for his mother Regina Sturzenegger to operate her Swiss embroidery factory near the home. Their descendants occupied a separate home for over 80 years located on the same 35 acres that the Sturzeneggers purchased in 1893.

CHESTER, N.J.                    Z 203

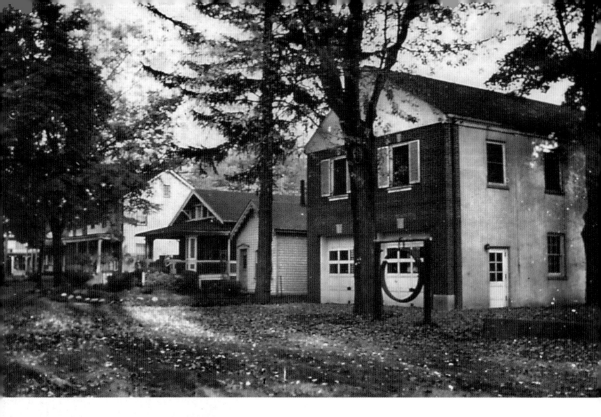

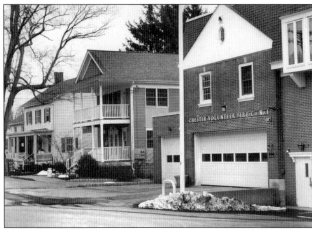

In the latter half of the 1800s, iron ore transformed Chester into a boomtown, but after the heyday was over, the town returned to its agricultural roots. The quiet village life continued until the 1970s when suburbia filtered into Chester. Many of our historic buildings, especially along Main Street, have been restored and are now used as restaurants, shops, and galleries.

This building along Main Street was built in 1870 by Jim Burr for Dr. Smith Hedges, and held Lon Green's pharmacy and George Conover's paint and wallpaper business in the front, and his printing business in the back. In the late 1880s, the post office was also in this building with Billy Dee as the postmaster in 1897. Later, it was also home to the telephone offices, where as one story goes, the lady operators made John Wyckoff run the switchboards at night, because they heard the bottles in the pharmacy rattling and knew it was mice.

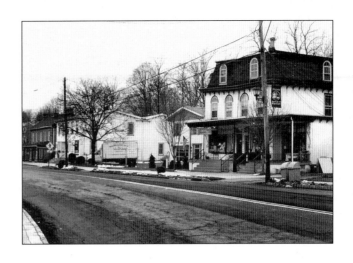

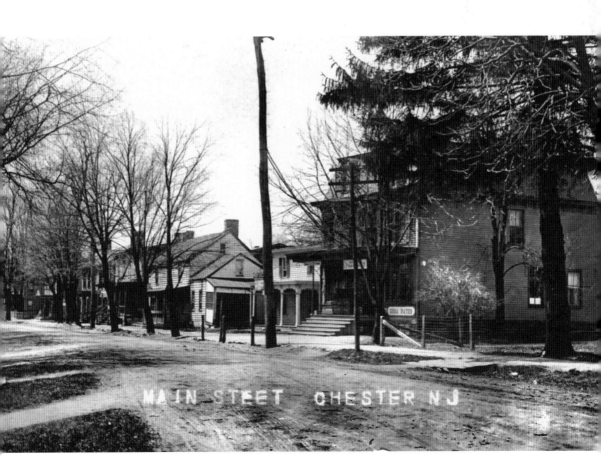

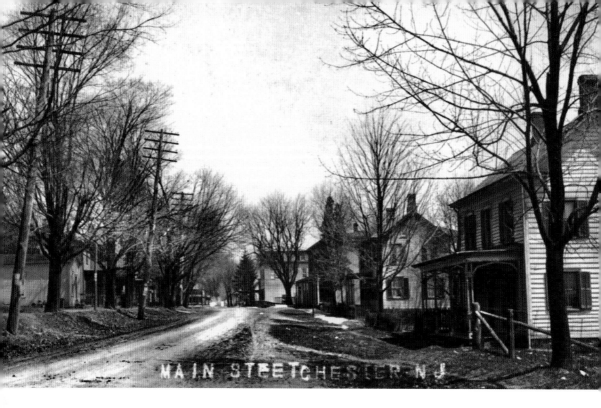

MAIN STREET CHESTER N J

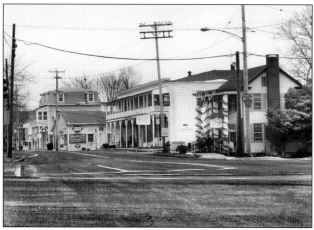

Looking east along Main Street, this was one of the original great roads that crossed in Chester. Just try to imagine what this road looked like over 200 years ago when it was just an American Indian trail. These photographs were taken near the intersection of Routes 206 and 513. Highway Route 206 was not built until the 1930s and was originally called Route 31.

The Washington Turnpike was chartered March 3, 1806, and Chester's Jared Haines was a director by owning 10 shares in the company. Land was donated for the turnpike by cutting a straight new road from the village center to the crossroads, which would have been from Hillside Road to Oakdale Road. The former highway that ran along Fairmount Avenue and down Budd Avenue was then referred to as the Old Road. In 1810, lots started selling along this new stretch of the Washington Turnpike.

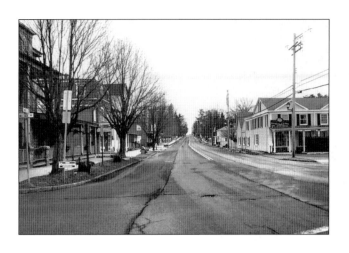

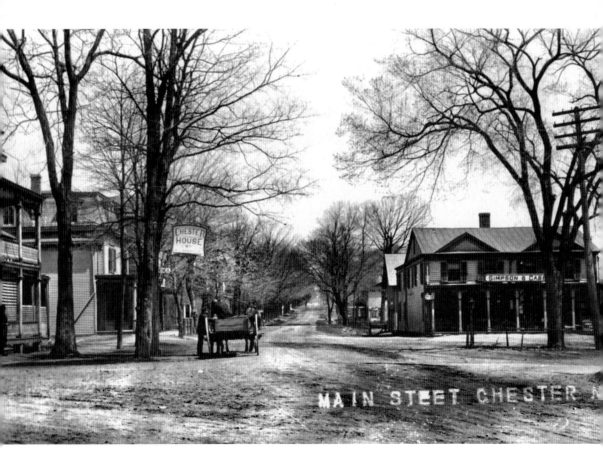

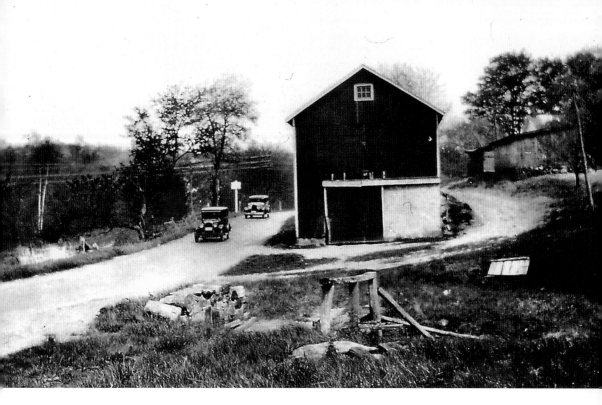

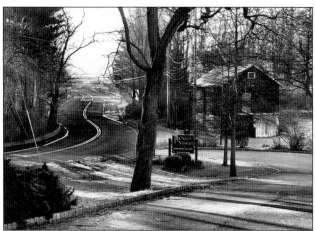

This barn, located along Route 513 in the Milltown section of Chester, used to be part of the Mountain Springs Distillery. Chester was known for its fine apple orchards, and there were many different distilleries producing "Jersey Lighting" applejack. The cider mill distillery was 55 feet long by 25 feet wide, with hand-cut and dressed beams. On the lower level, there was a room that was 25 feet by 40 feet. Water power came from an adjoining brook that emptied into the Black River. This property is now part of the Church of the Messiah.

In the 1740s, this property behind the building on the right was fenced by Benjamin Luse as a tavern lot so that drovers could turn their animals loose while staying at his tavern across the street. Later, Isaiah Fairclo operated a taproom in the basement where it reads, "W T B May 27, 1802," cut into one of the stones leading to the taproom. In 1810, Zephaniah Drake bought this property along with the tavern across Main Street, which he operated while the Brick Hotel was being built. Daniel Budd lived here in the 1850s, and when he persuaded William Rankin to come to Chester in 1854, the famous Chester Institute was opened in this building.

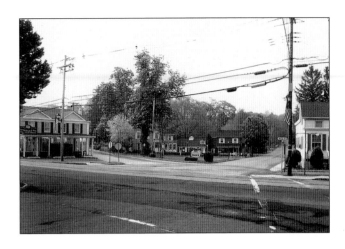

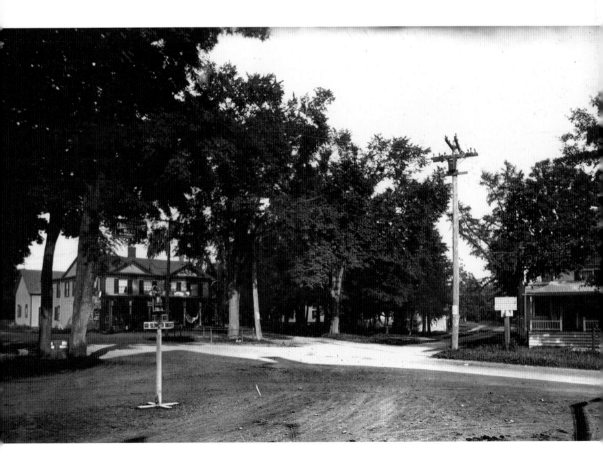

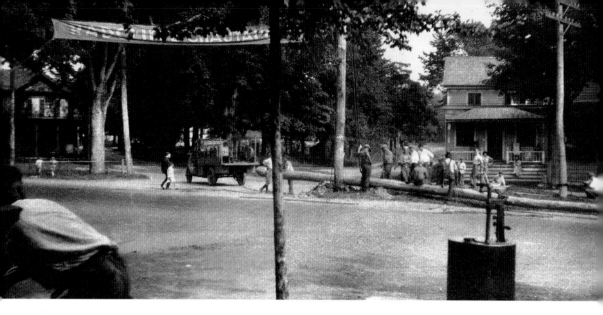

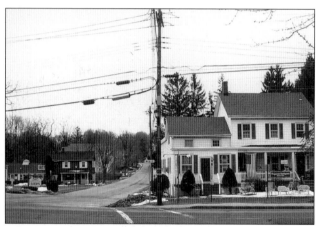

This flagpole was raised in the center of town in honor of the country's 29th president, Warren G. Harding, who died on August 2, 1923, at 7:30 p.m. The pole was raised, and the first flag flown on Monday, August 6, 1923, at 7:30 p.m. The pole had been taken from a forest near Silas Emmon's farm.

The Landing Road, which led from Brunswick Landing to Sussex County, was the route taken by the Chester Stagecoach that ran between the village and the Muskrat Depot until 1920. This is now called Hillside Road. On the right is the Brick Tavern, in the middle is Bizzy Lizzy's, and on the left is Pegasus Antiques.

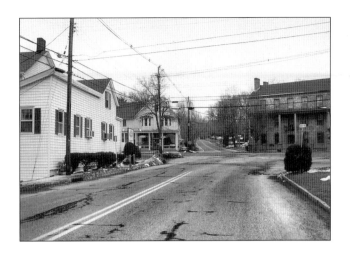

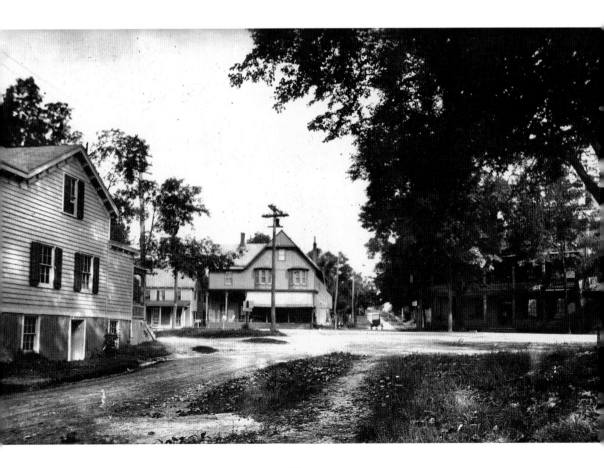

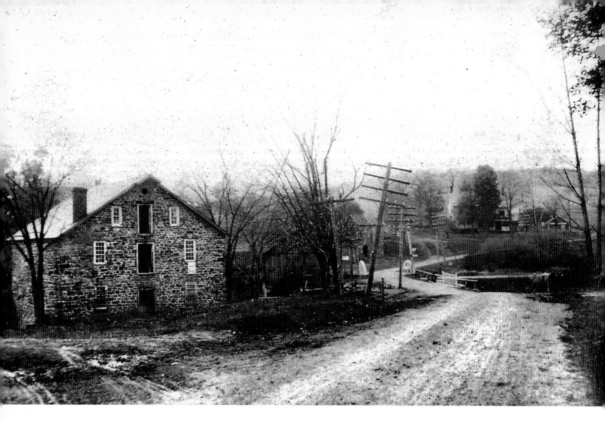

Before the invention of steam and electric engines, people harnessed the forces of nature to power the mills that ground wheat and other grains into flour. Frequently they settled in areas where fast-flowing rivers provided a reliable energy source. In the 1760s, one such person, Isaiah

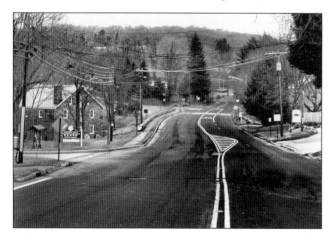

Younglove, began a flour mill at a site along the Black River in the village of Chester. The operation lasted until 1788. Another villager, Elias Howell, eventually took over the site and ran a gristmill and sawmill there until 1825. In April of that year, the mill lot was deeded to prominent businessman and landowner Nathan Cooper for the sum of $750. This included approximately 4.5 acres of land, a milldam, a gristmill, and a sawmill. The mill and surrounding area were known as Milldale, or Milltown, and also included a saw mill, woolen and shoddy mill, blacksmith, Hacklebarney Forge, and icehouses.

In 1898, John P. Rockefeller rented this Milltown store along what is now known as Route 513 and would drive a delivery wagon with a canvas top. At each house, he delivered the order for that day and took the order for the next. This building was destroyed by fire, and the Old Mill Tavern was then built. The Milldale post office was also located here in this old general store.

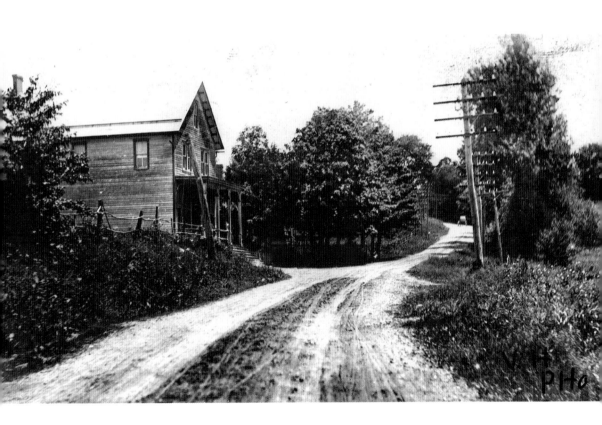

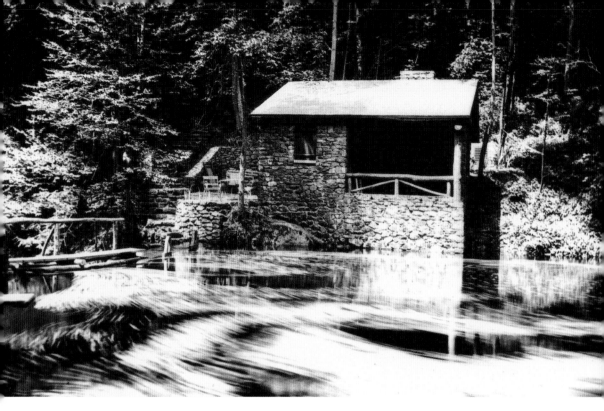

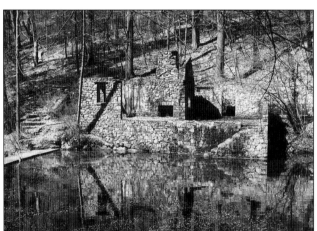

In 1915, Elizabeth Donnell married Alfred G. Kay, a stockbroker from Pittsburgh, Pennsylvania. The Kays moved to Chester in the 1920s where they spent their springs, summers, and falls. The couple wintered in Florida where they were involved in many community activities. The Kays bequeathed their 233-acre Hidden River Farm in Chester to the Morris County Park Commission, which dedicated the property as the Elizabeth D. Kay Environmental Education Center in 1994. These photographs show the pool house at the bottom of their hill. It was later set on fire by vandals.

In 1760, Richard Terry and his wife, Mary Horton, settled in Roxbury, of which Chester was a part of at that time. This house along Route 24 that Terry built remained in the family for quiet some time. Eventually, Deborah Terry (granddaughter of Richard) inherited the house. The house was moved to make way for a development, and it continues its life as a garage that is attached to the house in the newer photograph. The older photograph was taken in the 1930s.

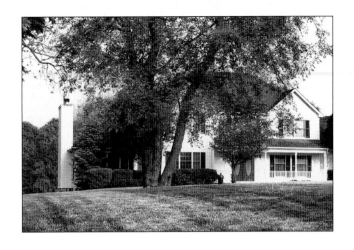

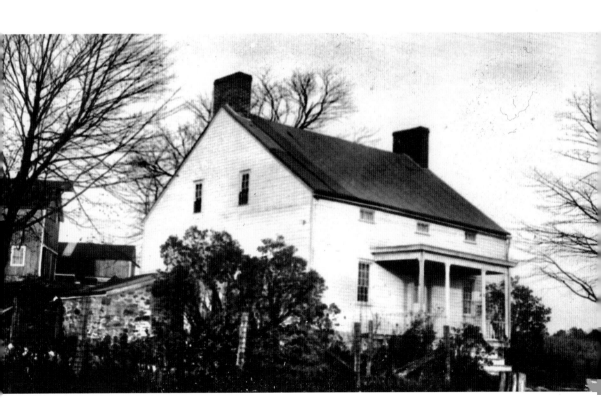

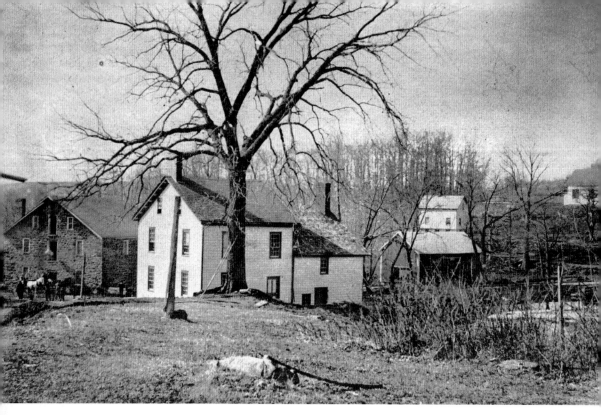

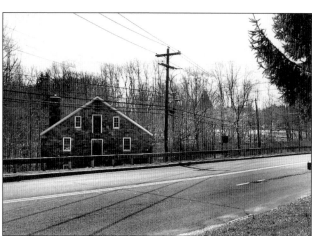

Nineteenth-century maps show that Morris County was dotted with many little villages much like Milltown. These communities arose at an important crossroads, largely to create a commercial and social center so local residents would not have to travel more than a few miles to shop and go to church and school. This older photograph shows the back of the Miller's house, and across the way, Cooper Mill, the saw mill, a bank barn, and the Milltown School, which is now the Chester township municipal building.

The Grogan family owned this property along Route 206, which not only had the Chester Retreat Nursing Home located on it, but also Chester Springs swimming pond and snack bar. This was a favorite swimming hole in the 1960s and 1970s. The pond was filled in and the nursing home torn down so the Chester Springs Shopping Center could be built on this site. (Courtesy of Willard Apgar.)

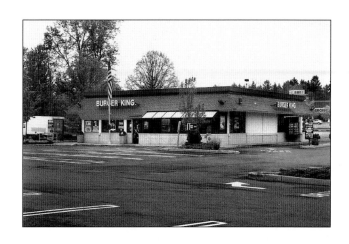

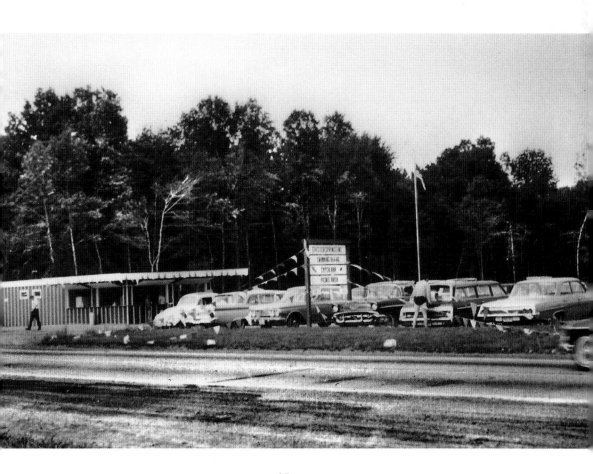

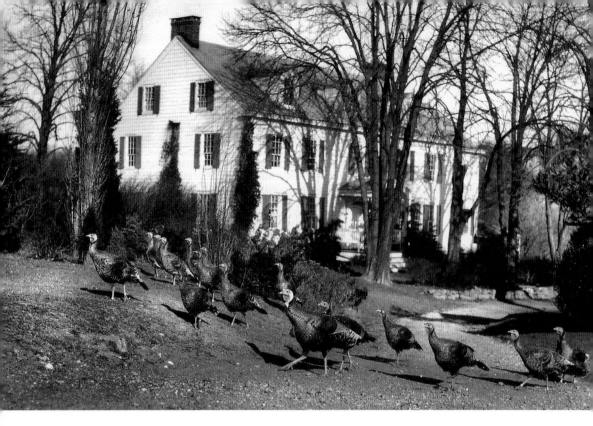

Originally from Kingston, Pennsylvania, Robert and Henry Tubbs purchased this property in 1908 from the Kennedy family, who had owned it for several generations. The Kennedy family named their property Paradise Farm, and the Tubbs brothers decided to rename it Willowwood after they purchased the 134 acres of hills, meadows, and woods. They found this an ideal setting of rich farmland with a farmhouse and outbuildings and magnificent vistas, where they made it their life-long avocation to collect and grow thousands of new plants. The property now belongs to and is run by the Morris County Park Commission. (Courtesy of the Morris County Park Commission.)

When the Tubbs purchased their country property, the buildings consisted of a main house, a wood-frame carriage house, an 18th-century barn of puddingstone, a shingled barn, a smoke house also of puddingstone, and a puddingstone cottage that was dated around 1823. Pictured here is the puddingstone barn, made of a reddish, mottled-colored composite stone found in New Jersey. The Morris County Park Commission has lovingly restored Willowwood to a public arboretum. (Courtesy of the Morris County Park Commission.)

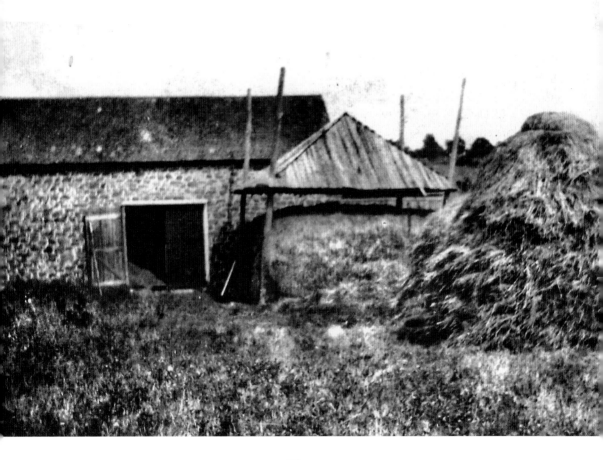

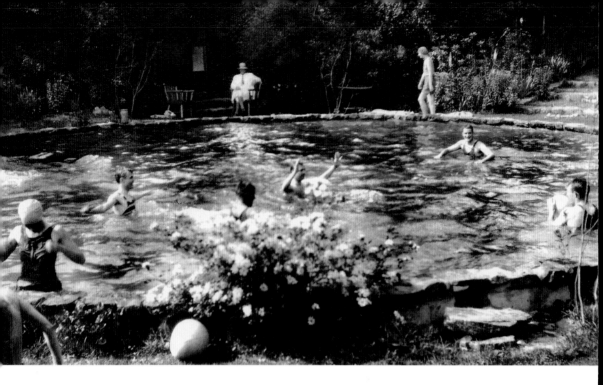

The Merchiston Farm, located on Longview Road, was purchased in 1912 by Martha Brookes Hutcheson and her husband. They lived in New York City and initially summered at their new country home. Eventually, the farm became their year-round residence and is now on the National Register of Historic Places. Built in the late 18th century by Huguenot immigrants who fled Catholic persecution in France, the land was owned by Frederick Hunnel through the first quarter of the 19th century. An addition replicating the existing dwelling was built in 1848, enlarging the home to a center hall with two rooms per floor on both sides. Merchiston Farm is a 100-acre estate comprised of a main house with five acres of designed landscape, a farm quadrangle of several buildings, and approximately 90 acres of fields and woods. The property retains much of the plans and features designed by Martha Brooks Hutcheson, such as this pool and gardens. The farm, now known as Bamboo Brook, is owned and maintained by the Morris County Park Commission as an outdoor education center for the study of horticulture. (Courtesy of the Morris County Park Commission.)

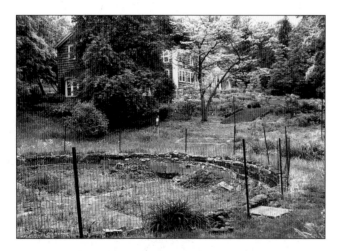

In 1810, Zephaniah Drake and his father, Jacob Drake, Jr., built the Brick Hotel, pictured on the left, which was also a stagecoach stop for a route that crossed the state. Each of the original rooms had a fireplace with a carved mantelpiece. In 1854, it was enlarged for a private school, and sometime after 1868, it became a hotel again. Daniel Budd had hopes of using this building for the Chester Institute, but decided there were too many rough mining men loitering around the area and moved it to another location away from the center of town.

*Chapter 2*

# BUSINESSES

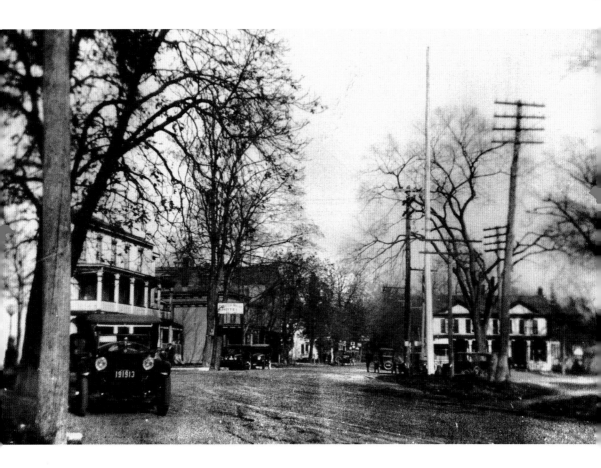

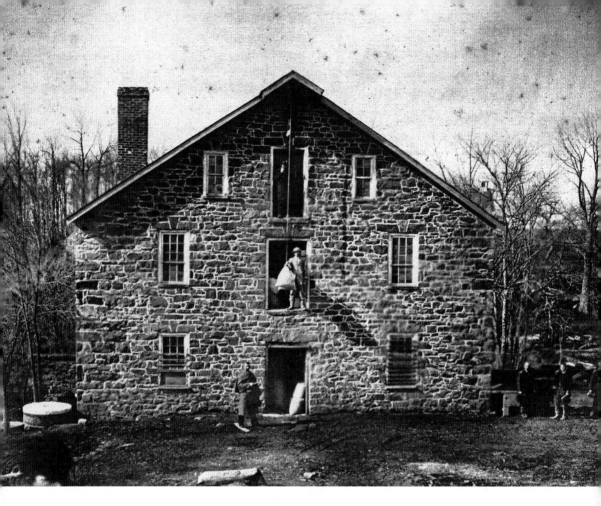

This gristmill was built in 1826 to replace a mill that had burned down on this same location. In 1913, the mill was closed and stayed

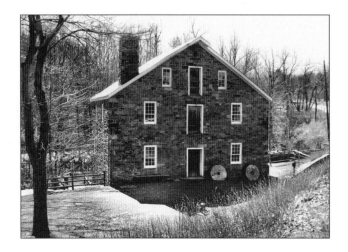

vacant until the Morris County Park Commission purchased the site from the John Kean estate and began restoration of the mill in 1963. It was here in the 1760s that Isaiah Younglove began a flour milling operation that lasted until 1788. Over the years, the mill went through several owners, with the present mill built in 1826 by Nathan Cooper. Through the 19th century, Cooper Mill remained the center of Milldale's community life. Here farmers gathered to have grain ground into flour, discuss news, and transact business. Visitors to Cooper Mill can watch the massive water wheel power the shafts and gears that turn 2,000-pound mill stones.

In 1906, L. T. Current purchased the Depot House at Muskrat near the D. L. and W. Station and renamed it the Anthracite Hotel. In 1912, he added on a sizeable addition and moved the bar up to the first floor. In 1925, after Prohibition had "spoiled" business, Current sold the business to William Kohler, who then sold it to Edward Hann. After the trains stopped running, Hann continued to operate the tavern with "rousing cockfights." After his death, the tavern was left to his niece, Luella O'Neil, who then sold it to Bernie Wallace. Not only named after the new owner and the road it sits on, the tavern is now called Bernie's Hillside.

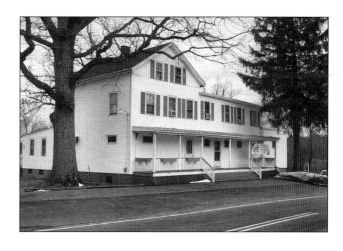

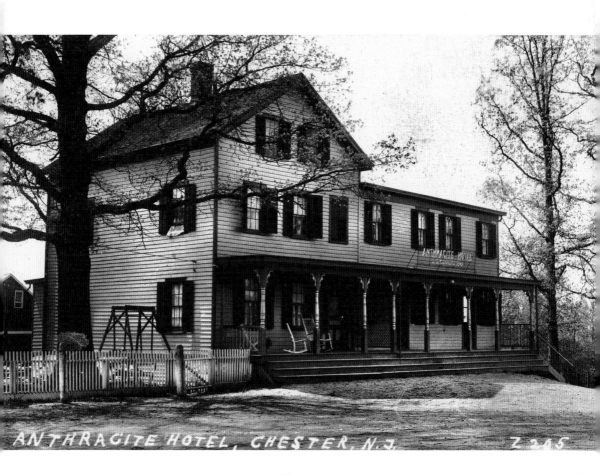

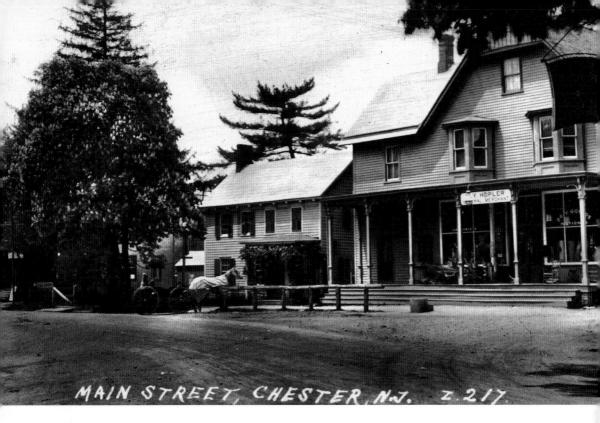

MAIN STREET, CHESTER, N.J. Z.217

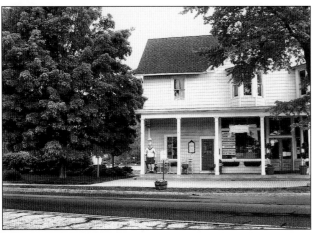

In the 1740s, Benjamin Luse operated a tavern on this site, which is at the intersection of the two great roads, Main Street and Hillside Road. By 1760, Thomas Fairclo owned it as a tavern, but by the time the Brick Hotel was built, this building became a store. Gilbert Hopler was a victim of a hold-up and murder while operating the store as it was pictured here in the older photograph. There was a back section which was the library for a time, which was demolished to build the parking lot. It was also used as the post office.

In this old factory building from 1844 through 1861, the Van Doren brothers manufactured threshing machines, and in 1857, the brothers introduced the first steam engine into Morris County. The building was Daniel Budd's machine shop in 1861, Davidson Manufacturing. Company Handkerchief's building in 1899, and J. W. Arrowsmith's arch supports manufacturing company in 1903, pictured here. This building sits in the center of town along Main Street and was also home to a bakery and Chester's first library.

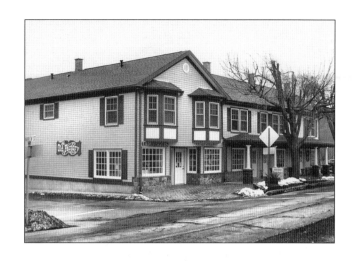

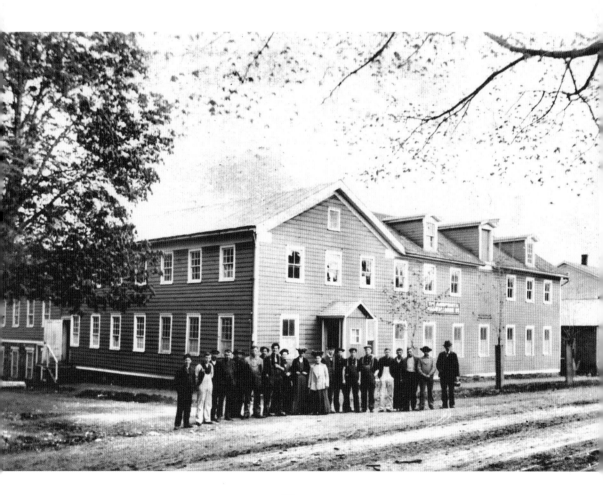

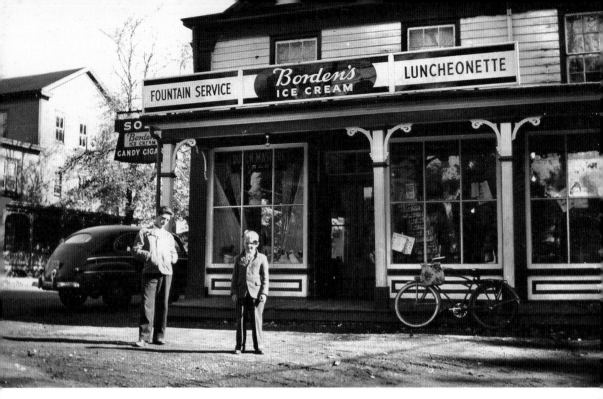

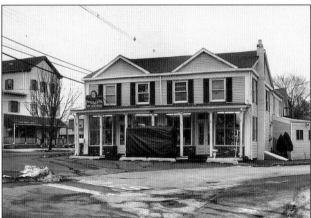

In the 1820s, this parcel of land belonged to Jacob Drake Jr., who built the Brick Hotel. On the 1868 map, it was the E. H. Dunham and Sons Store. In the late 1870s, this was the Simpson and Case store, and in the late 1920s, it was Fred DeHart's radio repair shop on the left and George Ulrick's luncheonette on the right. In the 1940s and 1950s, many remember this as Leck's Luncheonette, as it is pictured here, where there were many rows of jars with penny candies in them. This building sits at the corner of Main Street and Budd Avenue.

The Brick Hotel, now known as the Publick House at the intersection of Main Street and Hillside Avenue, was erected around 1810 by Zephaniah Drake and Jacob Drake Jr. Early in the 1850s, Daniel Budd and Theodore Perry Skellenger purchased the Chester Hotel for $3,650 with a fine new school in mind. They brought the renowned William Rankin to Chester in 1854 to conduct the famous Chester Institute. He started his school across the road while waiting for the hotel to be enlarged and made ready. The building is now in the planning stages for another restoration.

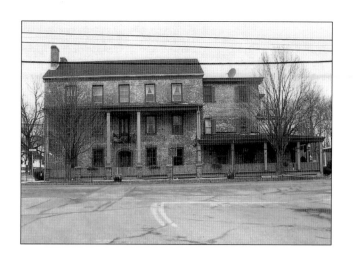

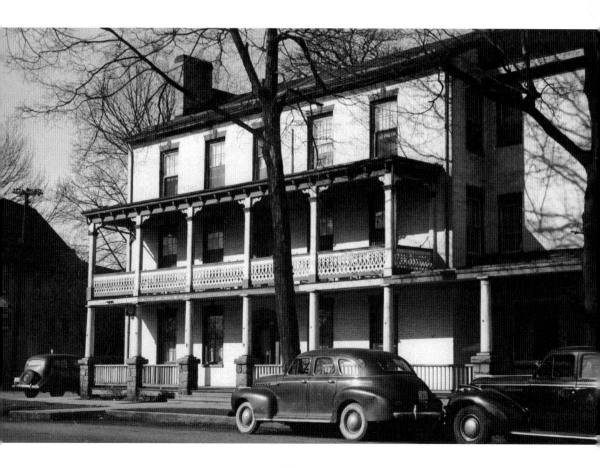

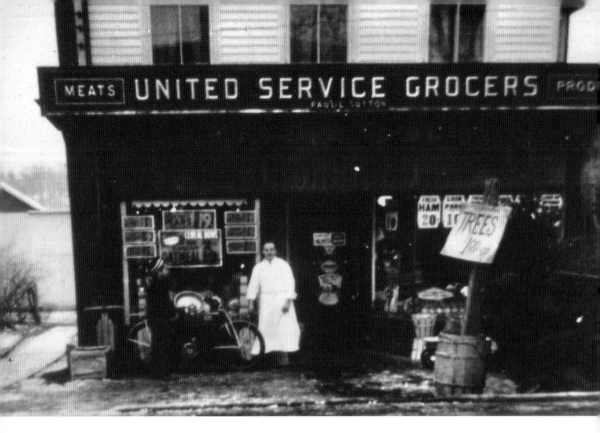

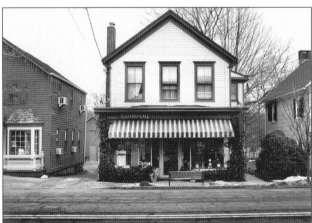

Prior to 1829, James Topping had his cabinet shop in this building at 58 Main Street while he lived across the street. In 1899, P. C. Yawger was a justice of the peace and his son, P. A., sold gents' furnishings. Pictured here in the early part of the 1900s, it was Sutton's Store, where Sutton was a butcher and ran the store also as a grocery store.

As the Hacklebarney and Milltown area developed, a number of mills were built along the Black River to take care of the needs of the farmers and residents of the area. Some of these mills were gristmills, saw mills, and shoddy mills. This gristmill pictured here along Hacklebarney Road is called the Lower Hacklebarney Mill and was used for grinding corn and grains. It is known to have operated from 1828 to at least 1916, and there was a saw mill located nearby.

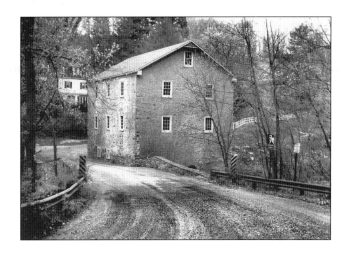

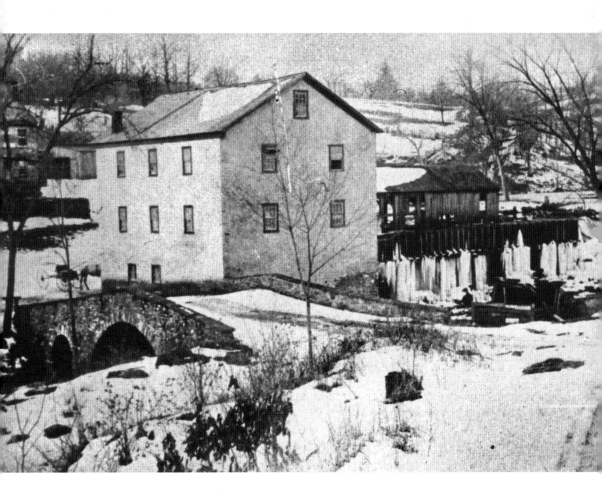

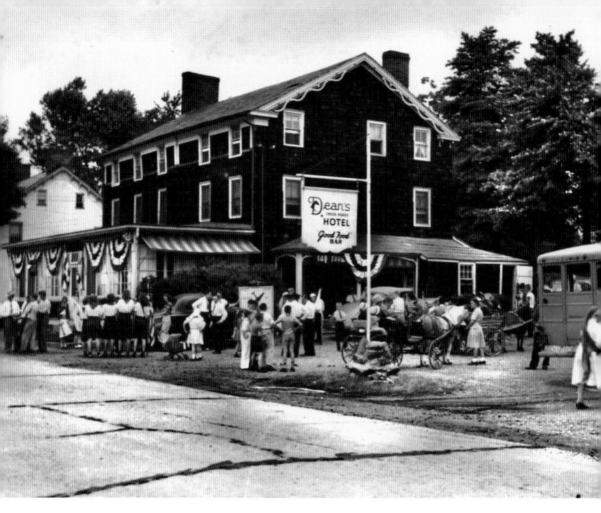

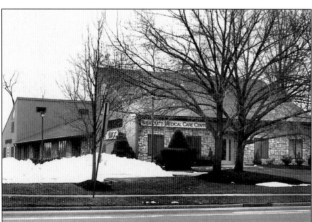

This farmhouse was built in 1752, and in 1779, Jacob Drake Jr. purchased it and turned it into a tavern and inn. It was called the Flagstaff Inn, and it operated as a tavern for the next 183 years until it burned down on November 26, 1962. It was called Dean's Crossroads Inn when it was destroyed by fire. The Crossroads Inn lot stood empty until 1982, when the Immediate Medical Care Center opened to the public.

"Perley" Peters was a local school bus driver who lived near this ice cream stand. Peters sold his school bus route to Albert Birkmaier. The stand, which was located at 335 State Highway 24, was also a vegetable market stand. This older photograph was shot in the early 1930s. The building now houses a dentist office.

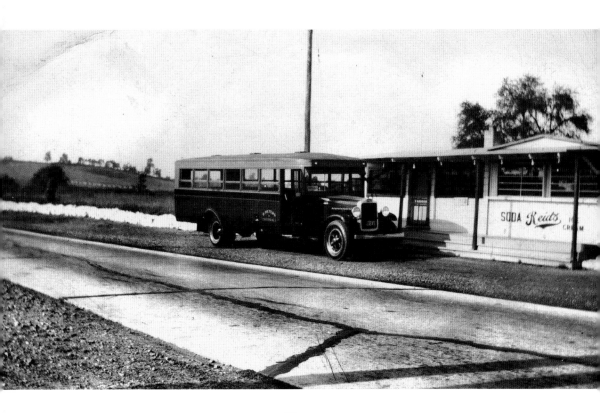

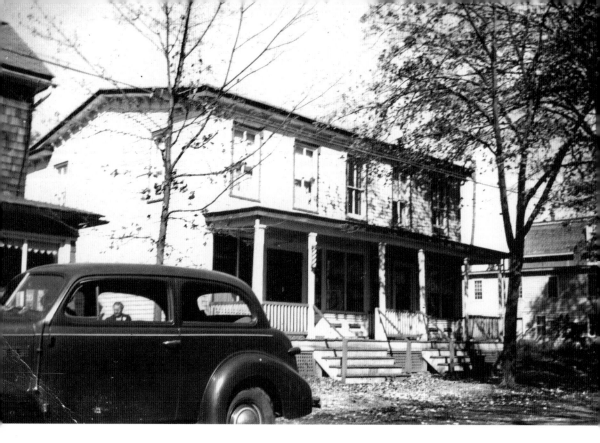

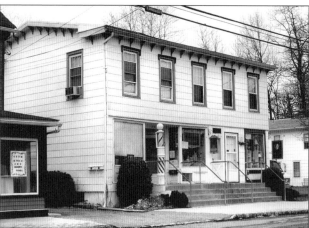

Charlie Tredway has been cutting hair at this 75 Main Street location since 1958 and still does today. Tredway purchased the building from John Fragman in 1965. In 1871, Isabella Skellenger bought the lot and erected a boarding house and restaurant to serve the miners. Skellenger's restaurant was on the right side. In 1897, Howell's general store was on the left with a long-distance telephone exchange room in the rear.

The Chester Railroad was chartered on April 2, 1867, and ran from a point on the Morris and Essex Railroad at Dover and terminated in Chester at this location. This Chester branch of the Delaware, Lackawanna and Western Railroad served the community well with not only passenger service, but freight service as well. Because of the mining in the Chester area, the railroad was a beneficial way to transport ore to its final destination. Simmonds Precision Company owns this 17-acre site located on Oakdale Road adjacent to the Black River. The manufacturing facility, which ceased operations in 1996, was home to the manufacturing and assembly of aircraft wiring harnesses and conduits for the aerospace industry. Wastewater generated in the metal finishing operations was discharged directly into the swamp and wetlands located north of the site from 1946 until 1972. In 1972, a percolation lagoon was

constructed to contain the wastewater. The old train station still stood proudly here until it was demolished during the clean-up activities in the late 1990's.

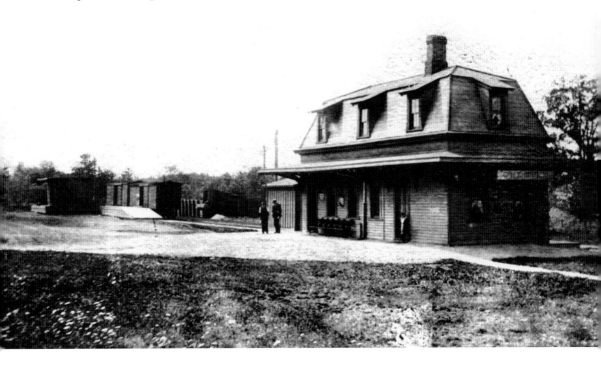

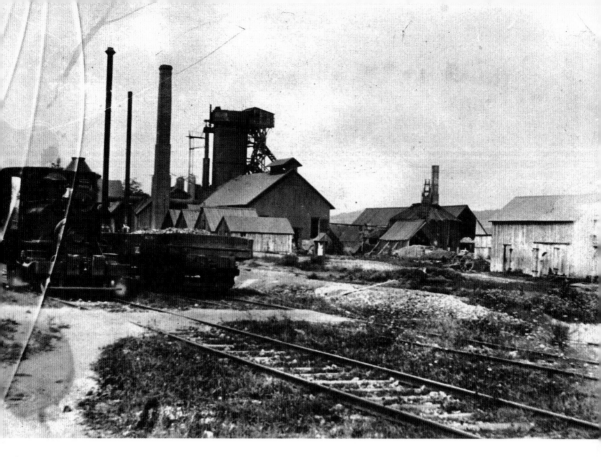

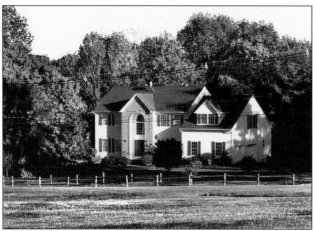

The Chester Furnace, which was located in the woods behind this house on Furnace Road, was built in 1878 by the Jersey Spiegel Iron Company. It was a blast furnace that was meant to make spiegeleisen out of the residue of Franklinite after the zinc had been extracted. It was abandoned almost immediately, and the furnace was leased to W. J. Taylor and Company of High Bridge. There were 100 men employed, and it was a successful blast furnace for a number of years.

This freight and sometimes passenger station was the station for the Chester Branch of the High Bridge Railroad. It was located near the intersection of Routes 206 and 513 where three coal yards were located. The High Bridge Railroad was built as a feeder to the Central Railroad of New Jersey to serve the mines of the Chester area, and it was intended primarily for shipping iron ore.

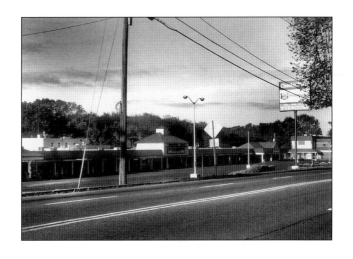

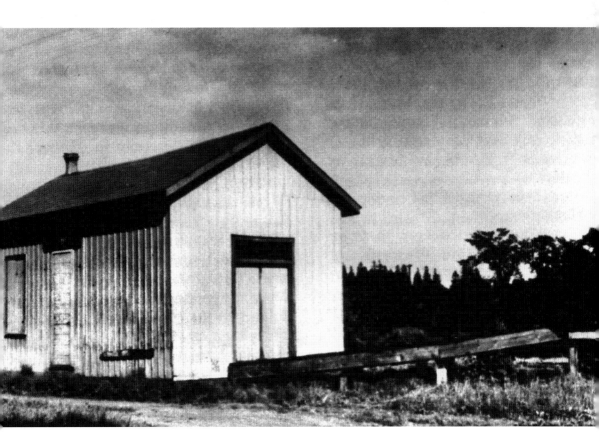

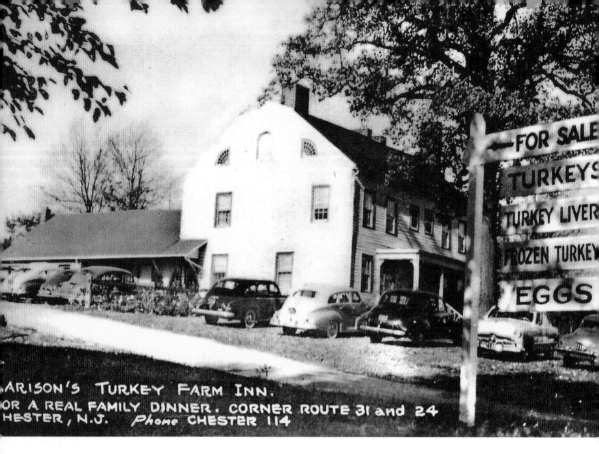

LARISON'S TURKEY FARM INN.
FOR A REAL FAMILY DINNER. CORNER ROUTE 31 and 24
CHESTER, N.J.   Phone CHESTER 114

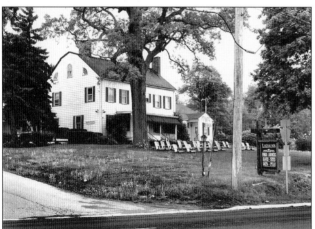

This farmhouse, which is now Larison's Turkey Farm Inn at the corner of Routes 206 and 513, was built by Isaac Corwin around 1800 at the site of the Benjamin Luse Farm. In 1829, James Topping bought it for $1,400, and in the 1940s, Willis Larison acquired the property at the close of World War II after he had spent 15 years raising turkeys to sell to the government. Two rooms from the *c.* 1736 house are incorporated in the present building and are part of the kitchen and serving area. The stones in the wall of the main dining room are also from the Luse farmhouse.

Many of the fine old brick homes in Chester were constructed from the bricks made at Nathan Cooper's brickyard, which was located on the south side of Cooper Lane. The brickyard is long gone now, but it used to sit in the woods behind the home pictured here. Note that the bricks on this home did not come from Cooper's brickyard.

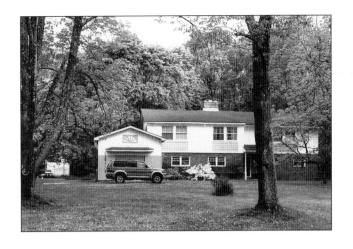

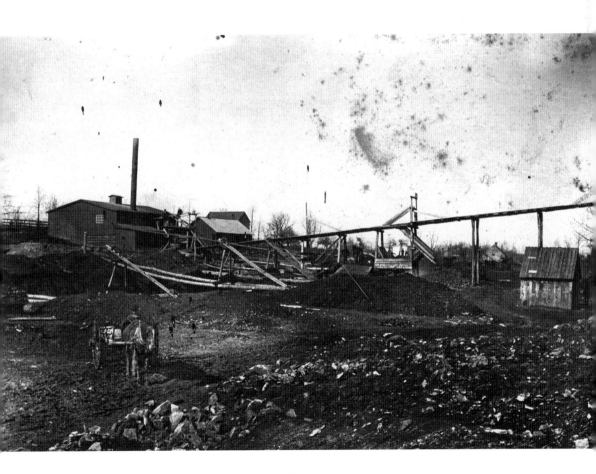

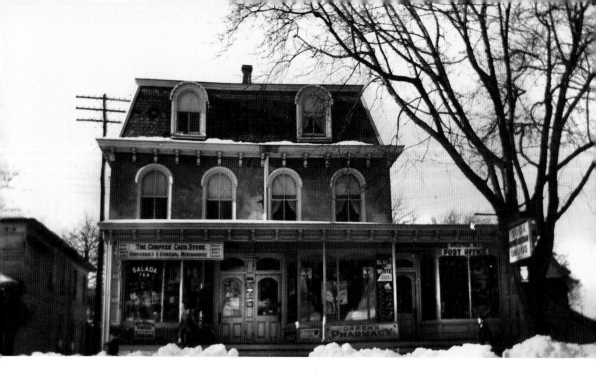

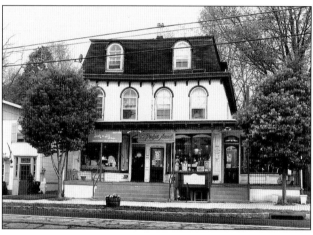

George Conover occupied the store at the west end of Lon Green's building on Main Street for many years, operating a printing shop, a paint and paper hanging business, and lastly, a general store. In 1919, he introduced to Chester what he called "a new way of shopping – cash and carry, with no monthly bills to pay." In order to get his message out, he started a monthly newsletter called *Conover Cash Store News*. It reported not only his store's specials, but also town news and history.

This building at the corner of Main and Perry Streets was once a livery owned by Theodore Perry Skellenger and a harness shop owned by S. Tredway. Later it was known as Morris Chamberlain's garage, which was completed in 1912 using molded cement block construction on the old fieldstone foundation of the livery stable. It has been reported that early Ford cars were assembled here after being shipped in via the railroad.

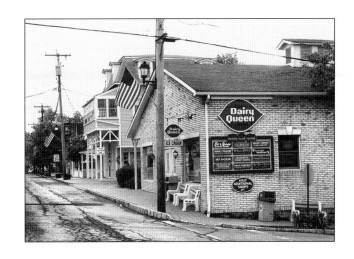

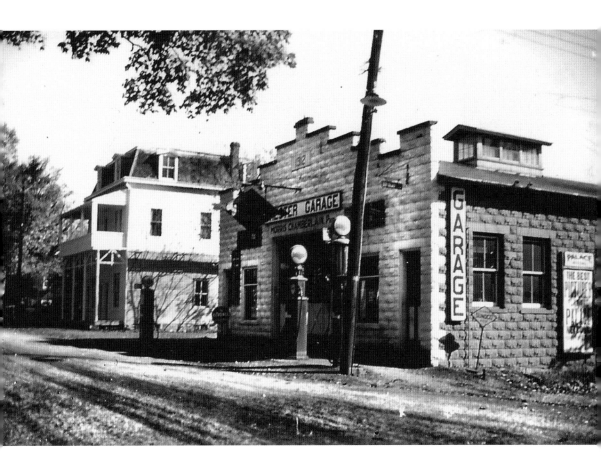

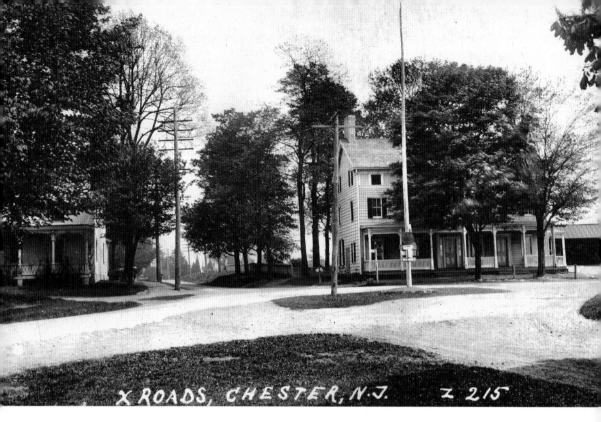

X ROADS, CHESTER, N.J.   Z 215

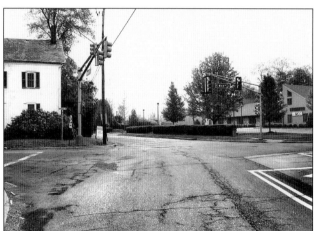

In 1779, Jacob Drake Jr. took over this beautiful old farmhouse, which was built around 1752, at the crossroads of Oakdale Road, Dover Chester Road, and Main Street. He converted it into an inn. A few of the names it held during its 183 years of operation were Jacob Drake's Tavern, Crossroads Hotel, Union Hotel, Flagstaff Inn, and Dean's Crossroads Inn. After it burned down in 1962, the lot sat empty for some time until the Immediate Medical Care Center was built.

This building along Main Street was built around 1865 by Charles R. Hardin for use as a bank, which it never became. The first floor became Hardin's Clothing Store, and the back end of the store was rented to James Tredway for his carriage shop. The mansard roof with multiple brackets was high style in the 1870s. From 1874 to 1951, Prospect Lodge No. 24 occupied the top floor. It is now one of Chester's fine furniture and gift stores called the Carousel.

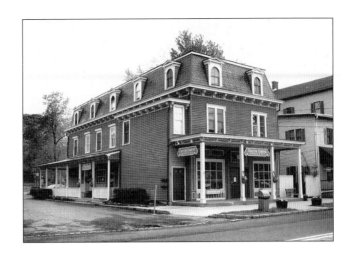

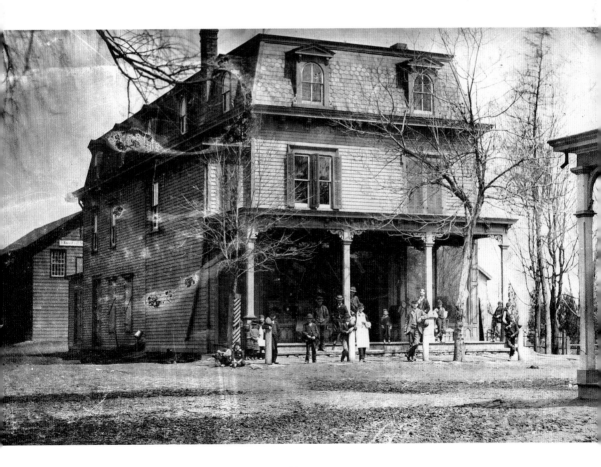

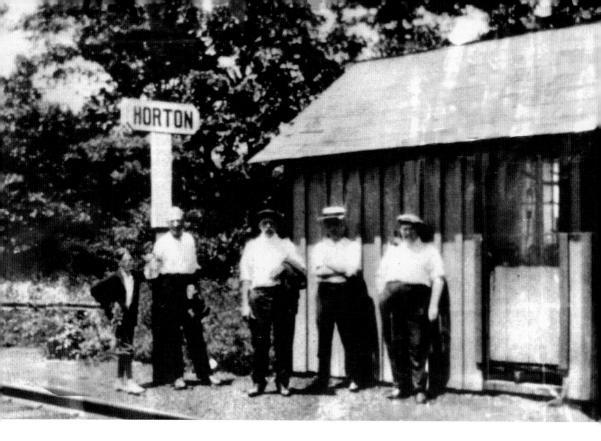

Pictured here was the small Hortontown Station on the Delaware, Lackawanna and Western Railroad line. It served the needs of this community well, and many remember riding the train to high school in Roxbury. The old train tracks have since been removed, and the Morris County Park Commission has turned them into hiking paths. Patriots' Path is a gradually developing network of hiking, biking, and equestrian trails linking several dozen federal, state, county, and municipal parks, watershed lands, historic sites, and other points of interest across Morris County. (Courtesy of Bill Crowley.)

In the 1850s, Chester reached a high level of prosperous living, with fine new homes, new churches, and its finest school. Enterprising citizens were turning to business in addition to, or in place of, farming. A typical new architectural design was that of the Mahlon Pitney and Henry Jacobson house located on State Park Road. The house, built by Mahlon's grandfather, Robert Dalzell Pitney, is on property that he purchased around 1830. It is still in the family and still producing wonderful apple crops. It is called Hacklebarney Cider Mill. Pictured from left to right are Robert, Charlie, Elizabeth, Amy, Andy, Elwood, and unidentified—all were Pitneys.

# Chapter 3
# HOME SWEET HOME

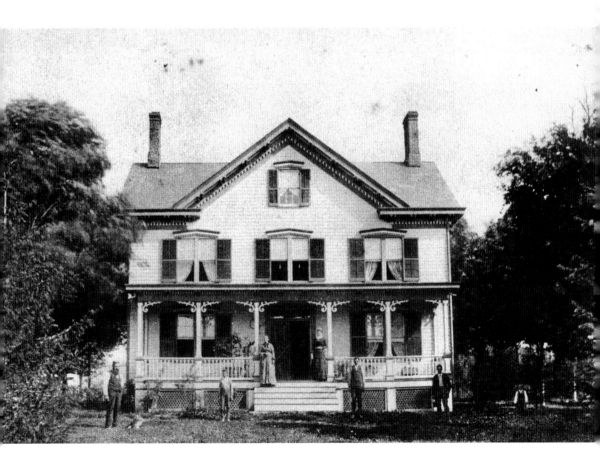

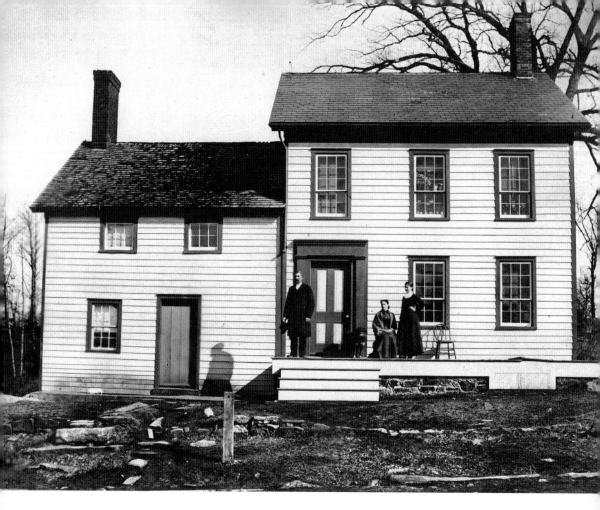

The Chester area changed dramatically just after the Civil War when, according to tradition, iron ore was discovered accidentally by someone digging a cellar along Chester's Main Street. During this time, the Hacklebarney and Milltown area continued to be the largest producer of ore in the area, and although it was a long-established mining district, there was not sufficient housing for all of the miners. Patch houses were built along Hacklebarney Road and along the road going into the village. Shown here is the miller's house that was located across the street from Cooper Mill. It was taken down during the road and bridge reconstruction in the 1970s.

This home, located at 76 Route 513, was built in 1747 by Samuel Swayze, the first judge in Roxbury Township (before Chester's incorporation in 1799). It faced the old road and was a two-story bank house with a sleeping loft and a cottage on the property that predates the main house by a decade or two. Both homes were built to face the original road, which is now their driveway, because the Morris and Washington Turnpike Commission relocated the road to the back yard in 1806, and it remains there today as Route 513. "Big Daddy" Zeek had lived in the home. He was known for the 1870s hanging wall accident that took his life off State Park Road in the open mines. (Courtesy of William Asdal.)

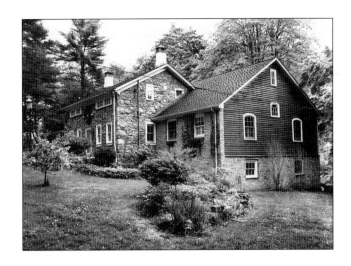

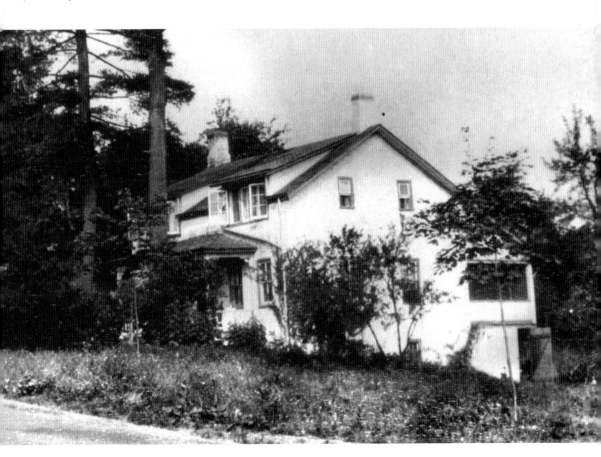

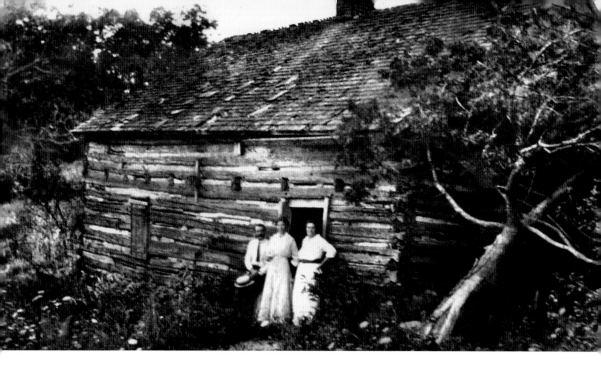

Hendrick (Henry) Wyckoff brought his family from Readington, New Jersey, in 1798 to Black River, later known as Chester. Many generations of the Wyckoff family lived in this log home and farmed the land. Descendents of the family are still in Chester today. Originally this log home belonged to minuteman John Emmons, who owned and farmed many acres in this area south of Chester near the intersection of Lamerson Road and Route 206. Pictured in front of the cabin are members of the Howell family. All that is left on this site are foundations and this spring. It has been noted in a letter in the Washington's Headquarter Museum Library in Morristown, New Jersey, that George Washington himself stayed in a log house one mile south of Chester. It is believed to have been this log cabin.

The Patrey family has lived in the Chester area since the late 1700s, and like many residents of that time, they were farmers. A few members of the family still reside in the area today. The home pictured here sat in the woods behind the old Patrey family cemetery on Fox Chase Road. Not only was the cemetery for Patrey family members, but also for neighbors and friends of the family. Some of the old families that are buried here are the Runyons, Wyckoffs, and Stouts. (Courtesy of Eunice Patrey Lee.)

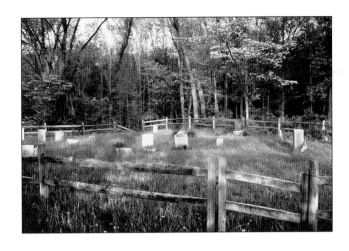

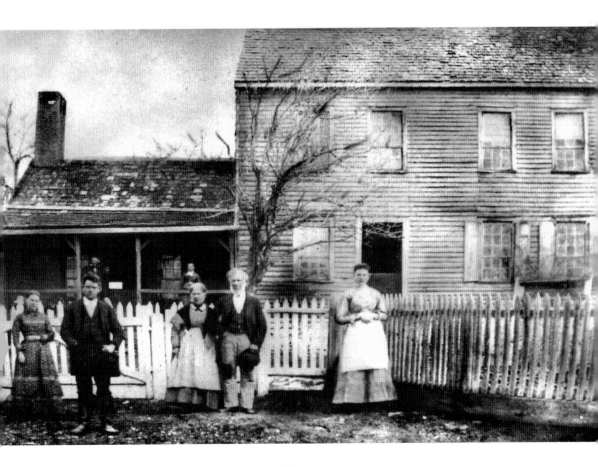

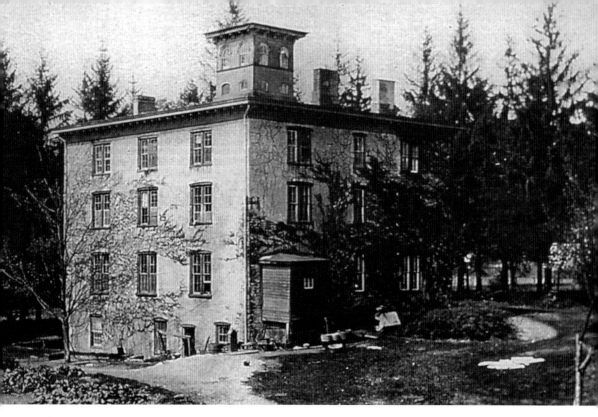

Daniel Budd built this 26-room stone house in 1868 as a home for his family and for the use of the Chester Institute, a private seminary school for young ladies. Around 1900, the Budd family changed the school into a boarding house. In 1945, William Mangels purchased it, started his candy business here, and also took in summer boarders. In 1957, the house was sold again, this time to the Grogan family for the purpose of creating a nursing home called the Chester Retreat. In July 1974, dozens of onlookers watched as workers destroyed the building to make way for a new shopping center.

James Haines of Parker Road died February 22, 1807, and left this property that he had purchased from Caleb Swayze to his only son, Jared. This property was located on the old road to Hacklebarney, which is now part of Hideaway Farm. The home was built around 1800, and Jared lived in the house for many years. He became one of Chester's most civic-minded men, serving as a township committee member, justice of the peace, a promoter of the Chester Academy, a director of the Washington Turnpike, and an elder of the Presbyterian church. It had been written that George Washington and other army officers were entertained here, and Chester men set a barn near the house on fire because British spies were thought to be inside. As pictured here, the house now stands in ruin.

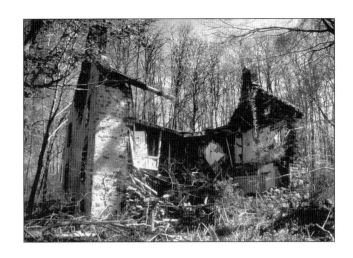

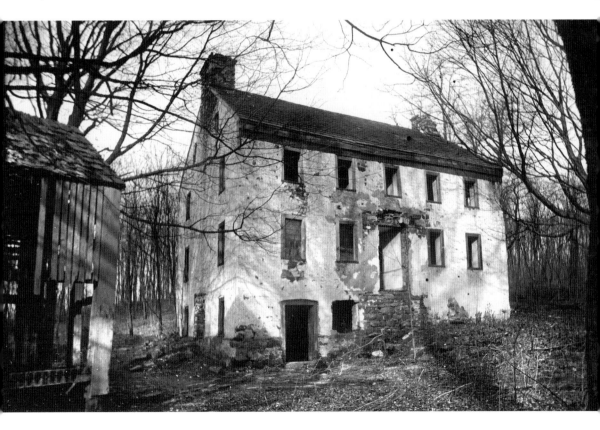

This was the home of Lank Burd on Oakdale Road, which was fondly called Lank's Inn by the locals. In the 1940s and 1950s, it sat across the street from the town's baseball field. Many of the good ole boys would come and sit on Lank's porch to watch the ball games and sip a few suds.

Formerly a Sears-Roebuck pre-fabricated California-style bungalow known as Conover's Cottage, this building was renovated in 1998 into a two-story commercial and residential building. It sits along Main Street, and the Rockefeller family rented the cottage and the little building next to it from George E. Conover. During this time, Carlos "Rocky" Rockefeller used the small building next door to the cottage for a bicycle shop and to sharpen ice skates. Later, his wife, Gert, used the building as a card and gift shop.

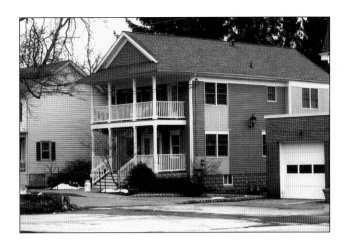

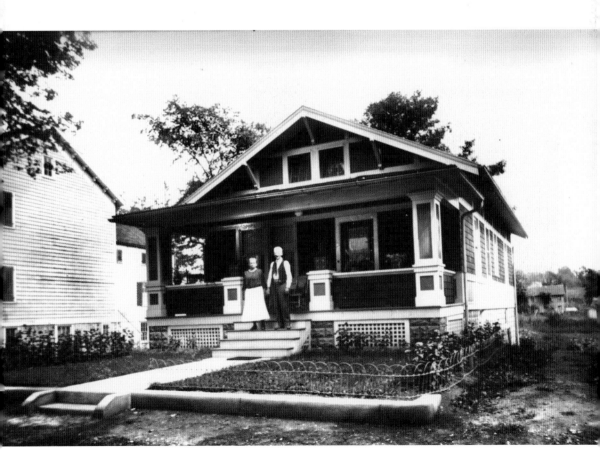

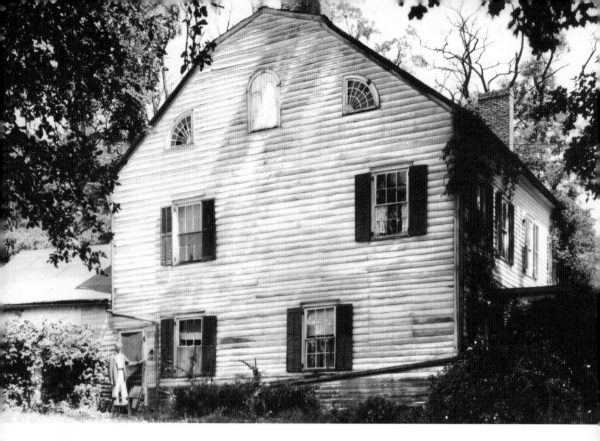

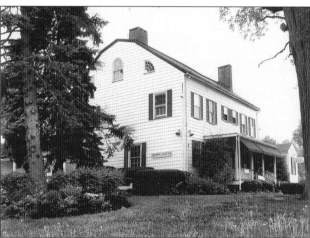

This house, which is now Larison's Turkey Farm Inn, was built by Isaac Corwin around 1800. The part-brick, part-stone rear wing with free-standing chimney may remain from an earlier house that was incorporated into the present building. James Topping, master cabinet maker, moved here in 1829 and used two rooms in the back wing as his workshop. In the 1940s, Willis Larison acquired the property and ran a very successful restaurant for many years.

The Red House Lot sat next to the old Luce Tavern at Hillside and Main Streets. In the early 1800s, when it was Fairclo's Tavern, John Calvin Corwin ran the inn for Isaiah Fairclo. Corwin may have built this house and painted it red, which gave it the name Red House Lot. Later, the Hopler and Mack families lived here while operating their general store. Gilbert Hopler was a victim of a hold-up and murder while working in the store. (Courtesy of Clinta Mack LaValley.)

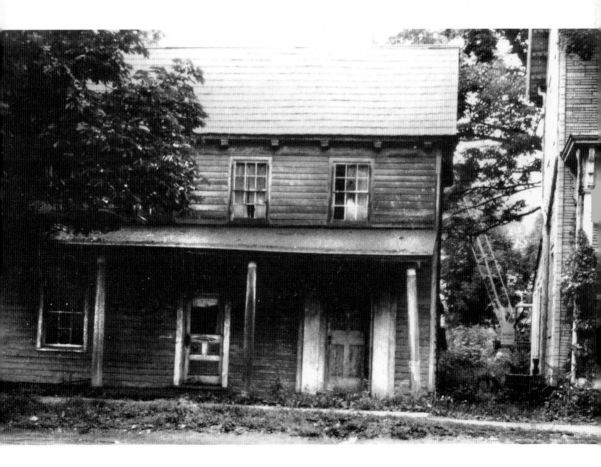

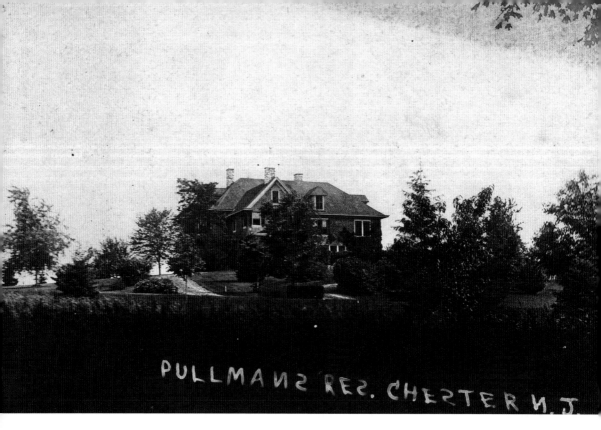

PULLMANS RES. CHESTER N.J.

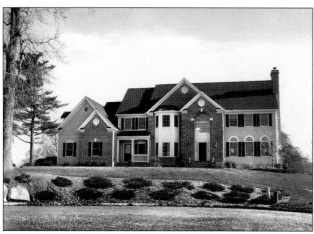

The home pictured here was one of the most beautiful homes of Chester's yesteryear. Occupying one of the heights of Chester, this magnificent home was owned by linen merchant Samuel C. Pullman. It was an elegant villa called Stonybrook Farm until it burned down around 1960. It was replaced with the Harvey Guerin home, which eventually was torn down to make way for a new development.

Philip Weldh, who operated a general store near the crossroads, lived in and most likely built this home at the corner of Main Street and Sentry Lane. Elmer Searles came to Chester from East Orange after retiring and purchased the house from Mrs. J. D. Evans. He called his home Robin Hurst because it attracted so many robins. At one point, he bought some of the abandoned buildings at the Hacklebarney mines and used the material for new outbuildings behind his new house. It is now the location for the Chester post office.

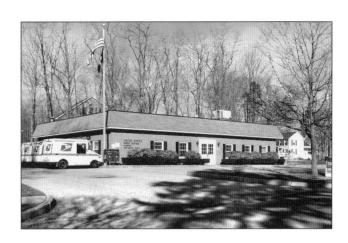

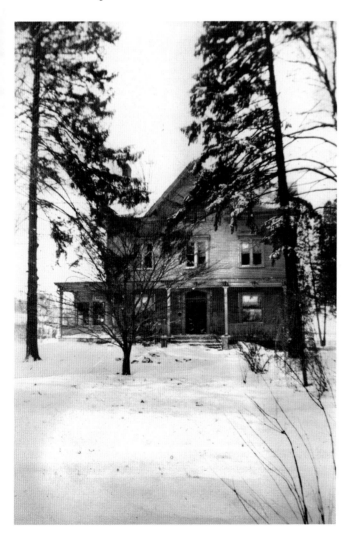

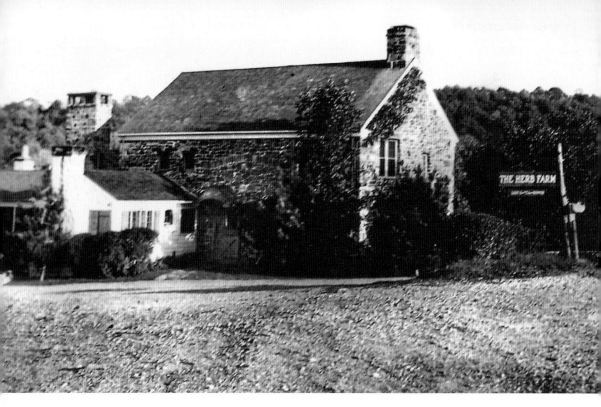

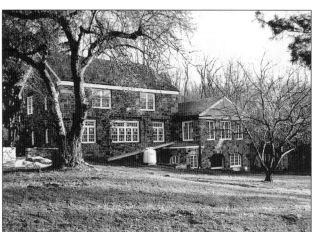

For over eight years in the 1930s, people, including such celebrities as Duncan Hines and Mary Margaret McBride, came to enjoy the delicately herb-flavored food served at the Herb Farm. For a number of years before, Mrs. Alfred Kay of Hidden River Farm had become fascinated with herbs and began not only growing them, but selling her herbs all over the world. This tearoom, located on State Park Road, was created to answer the summer job need of two Florida girl scout leaders, who happened to be very good cooks. The Herb Farm carried on until the attacks at Pearl Harbor brought World War II to the United States, and this old converted stone barn was sold to begin life as a private home. It is now in the process of being remodeled.

The home pictured here on Pleasant Hill Road near the cemetery was built in 1836 and was originally the farm house for the Swackhammer family. Later they sold the property to the archdiocese of Patterson, which used it as a retreat for their priests. Eventually Miss Mooney, a lady who loved her many cats, owned the farm and kept them in the barn across the street. The home is now lovingly taken care of by Chris and Jerry Smith. (Courtesy of Chris and Jerry Smith.)

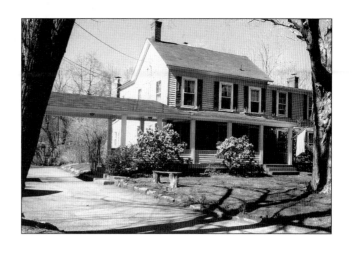

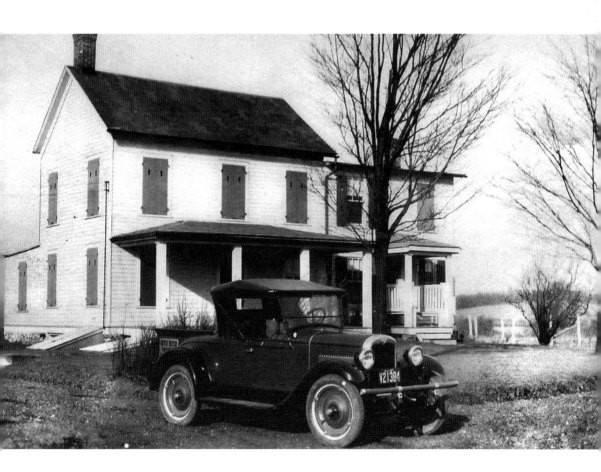

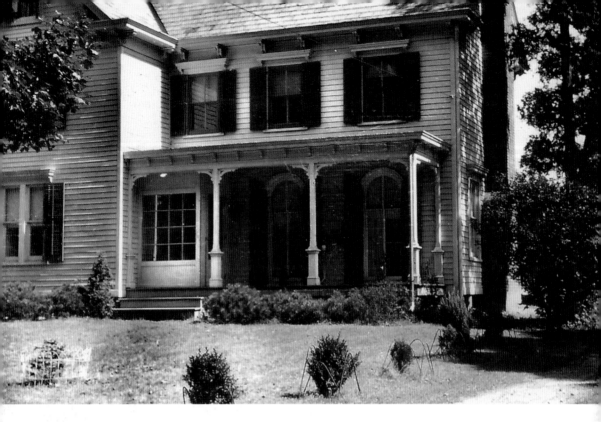

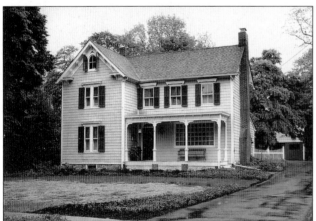

Written on a beam in the basement of this home is the date the house was built, September 7, 1872, with only the initials "W. I." as the builder. The Chester Iron Company owned the land in 1869, and Lewis W. Langdon purchased it on September 6, 1870, to build his family a home. In June 1928, J. Cecil Hoffman purchased the home and kept it until he sold it to Harold F. Hopping in June 1939. This Fairmount Avenue home has been in the Hopping and MacDougal families since that time. It is believed that the twin home on the opposite page was built by the same builder. (Courtesy of Ruth Hopping MacDougal.)

This home on Fairmount Avenue is the twin home to the Hopping and MacDougal home on the opposite page, but was built a few years later in 1874. It is believed to have been built by the same builder. This newer home has a little more gingerbread than its twin does, and it is a bit smaller. (Courtesy of Thomas Moke.)

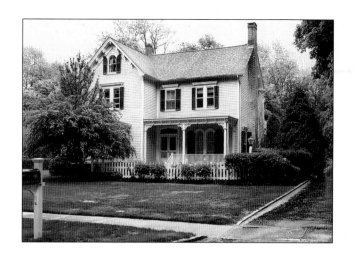

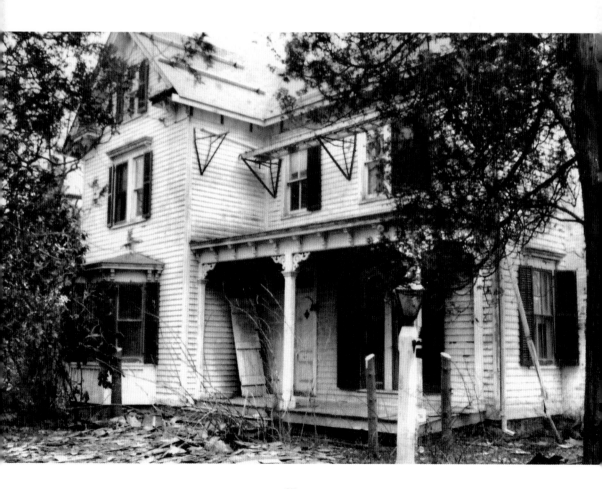

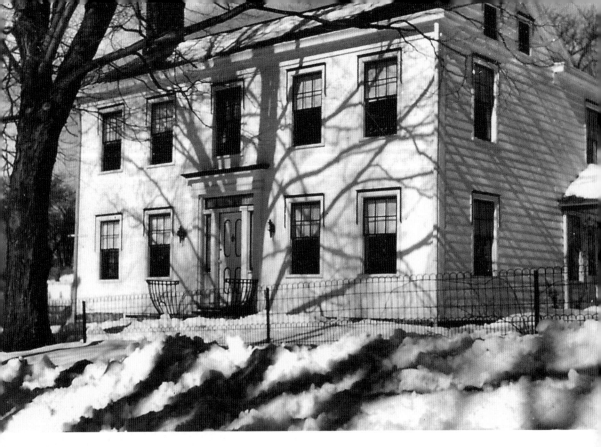

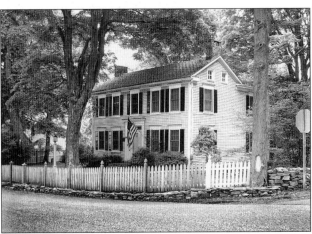

This house at the corner of Budd Avenue and Church Street is where Theodore Perry Skellenger lived in the 1850s and 1860s. The 1868 Beers Atlas map shows T. P. Skellenger as the owner of a livery stable at Main and Perry Streets in Chester. Some thought of him as an impractical man because of his planting of many trees along Chester's Main Street, but today's residents enjoy seeing the memorials he left behind. His discovery of iron ore on his Main Street property led to the mining boom in the 1870s and 1880s. (Courtesy of Ruth Hopping MacDougal.)

This property located at 31 Hillside Road is commonly referred to as the Hedges House. Five generations of physicians came from the Hedges family in Chester. Dr. Woodhull Hedges purchased this farmhouse in 1821 and subsequently enlarged it. For more than 100 years, it stayed in the Hedges family until it was sold to Austin Thompson in 1921. The center section, which was the original house, had two rooms, a large fireplace, and a narrow staircase to the upstairs. The kitchen lean-to was probably added next and much later the larger main part of the house. It stands sideways to the road as did many early farmhouses did so the living room and kitchen would face south to have sunshine all day.

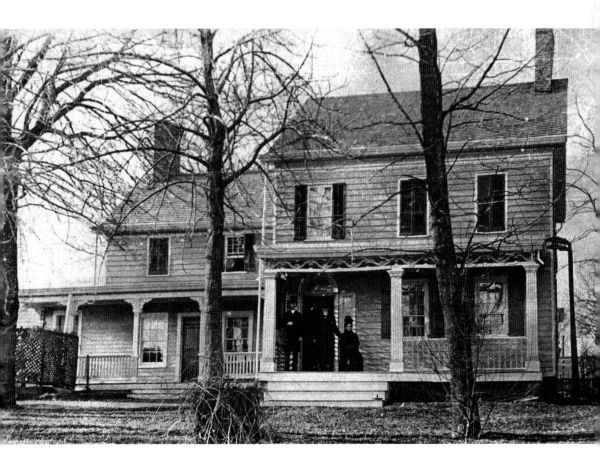

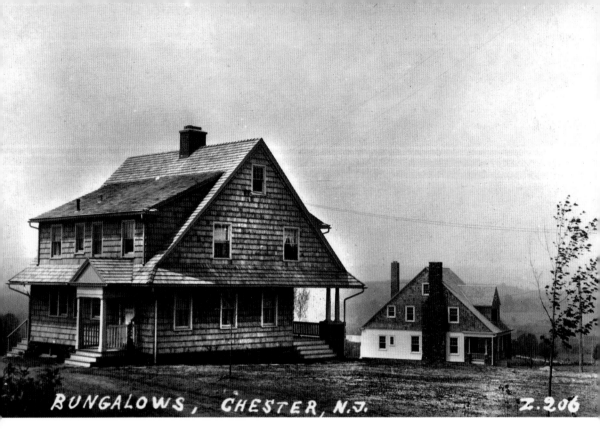

BUNGALOWS, CHESTER, N.J.     Z.206

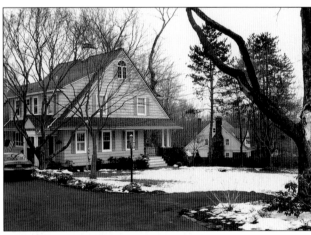

There was an increased demand for housing after World War I, and with recent improvements of transportation, suburbs developed. The Victorian-era homes were above the affordability of the average home buyer, especially in the Chester area. Bungalow-style homes were popular from about 1908 to around World War II, and many were built like these pictured along Hillside Road.

Early in the 1850s, Daniel Budd and Theodore Perry Skellenger purchased the Brick Hotel with a fine new school in mind called the Chester Institute. Budd started his school in the present Pegasus Antiques store across the street while waiting for the hotel to be enlarged and made ready. Budd decided there were too many rough mining men loitering near his Main Street school, so he built this 26-room stone building in 1869. It not only served as the Chester Institute, but was large enough to make a home for him and his family. It later became the Chester Retreat Nursing Home on Seminary Avenue before it was torn down in to make way for a new shopping center.

*Chapter 4*

# CHURCH, STATE, AND SCHOOLS

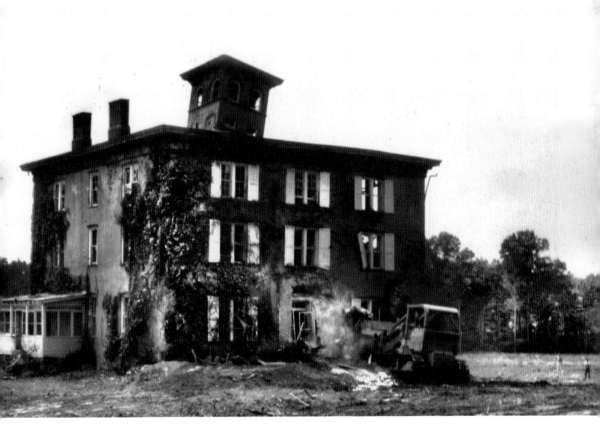

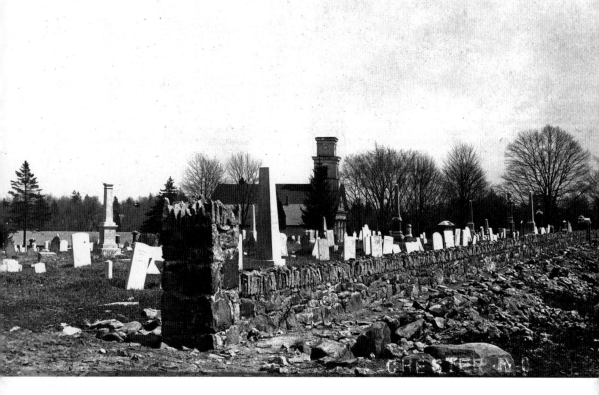

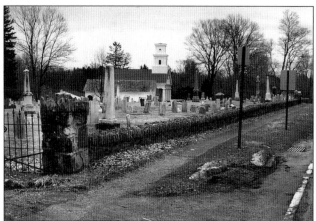

The Chester Cemetery Association was formed on January 1, 1910, and the land occupied by the cemetery was deeded to the association by the church so affairs of the church and cemetery would be separate. At a meeting on September 30, 1910, it was voted that a new stone fence be erected on an old foundation along Railroad Avenue for the cemetery that sits beside the Congregational church. On October 17, 1910, the association's grounds committee submitted plans and specifications for the new fence, and the lowest bidder was Coleman and Bunn for $425. The fence was to be 448 feet long, 18 inches wide, and 20 inches high, with a six-inch coping of German Valley trap rock and set on an old foundation. In the 1950s, John T. Wyckoff repaired it for the association, and it was again repaired it in 1999.

Once a Baptist church in Bedminster, it was purchased in 1854 by the Methodist Episcopal Church and moved to Chester during winter of 1880–1881 and was placed at the corner of Grove Street and Maple Avenue. It was moved in large sections by six mule teams. In 1911, a new Methodist church was built on Main Street, and the township purchased this building for $550 to be used as its municipal building. It now belongs to the Chester Theatre Group, which performs their productions at the building now called the Black River Playhouse.

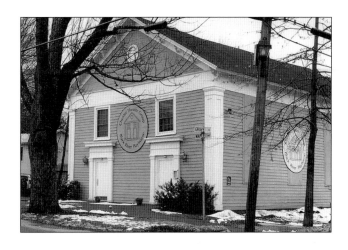

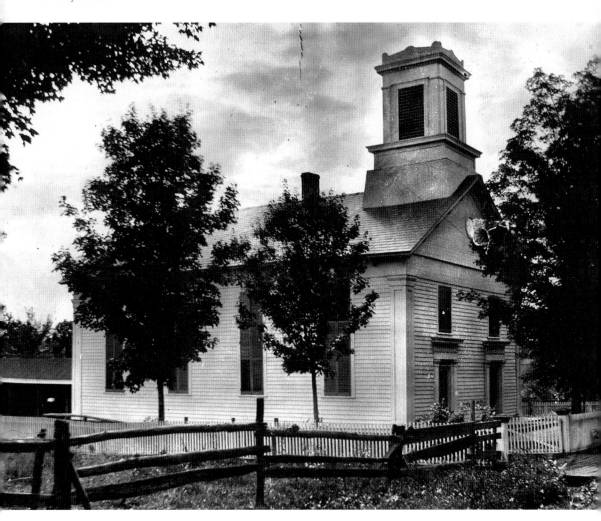

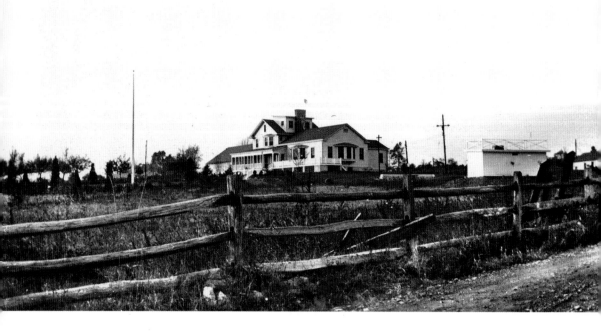

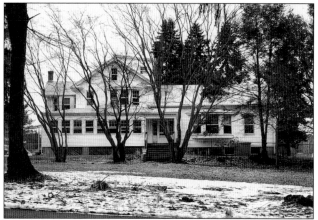

This 1940 photograph shows a farm that belonged to the Mercadante family. In the 1960s, a new type of independent, interdenominational church came to Chester. It was called the Grace Bible Chapel and occupied an old farm on Oakdale Road. The original farm produced not only regular farm crops, but also raised chickens. On the more than 10 acres that the church purchased, there was a built-in swimming pool, fireplaces, a field house, a gym, barns, and a bunk house. Evangelistic churches of the New York area often used it for youth activities.

The Black River Presbyterians originally worshipped with a congregation in Mendham, but soon after 1745, they organized the First Presbyterian Congregation of Roxbury. Around 1750, William Larrason donated a piece of land at the crest of Pleasant Hill for a church and burying ground. The earliest building was small and made of logs and served as the church from 1751 to 1756. It was called the Old Hill Church, and the name Pleasant Hill was not to be used for 100 years.

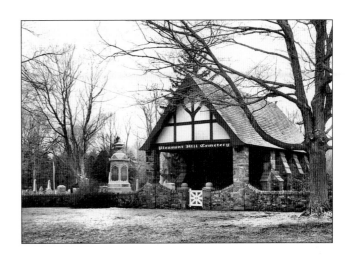

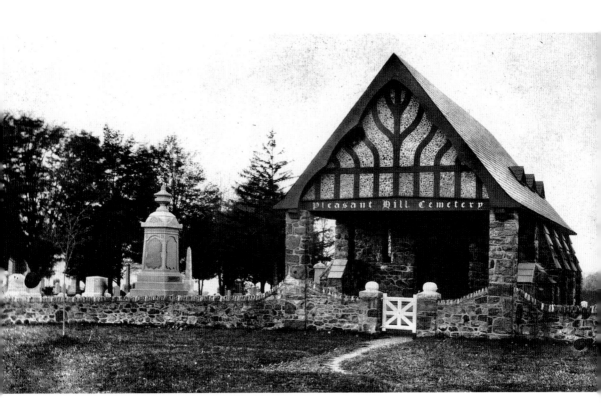

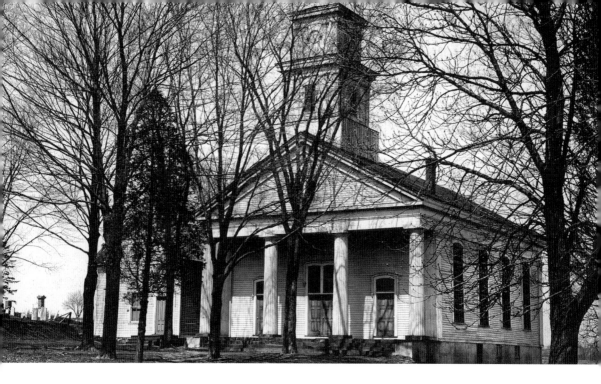

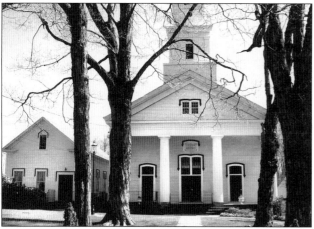

Around 1736, what we now know as Chester Borough was divided up and sold in three parts to gentlemen from Southhold, Long Island, who had farming in mind. They were also strong Congregationalists. Because they were few in number, they joined with the Congregationalists in Ralston and Mendham and worshipped together in a log meeting house that they erected in the Roxiticus area. In 1747, the Congregationalists found themselves able to erect their own meetinghouse along Hillside Road. The first site of the church was described as across Hillside Road from the cemetery. Samuel Swayze Jr. was the first pastor of this church. He was installed in 1753 and served for about 20 years. In 1772, he led a group of 72 families from Black River to 14 miles south of Natchez, Mississippi. The present church site was built in 1856 and is the oldest Congregational church west of the Hudson River.

The interior of the First Congregational Church is one of perhaps two remaining examples of trompe l'oeil decoration in the state. The beautiful decoration was restored in 1986 by M. A. Murdolo. The decorated tracker organ (Opus 128), built by J. H. and C. S. Odell in 1873, is used for regular services and was recently restored in 2004 by Meloni & Farrier Organbuilders of Port Chester, New York.

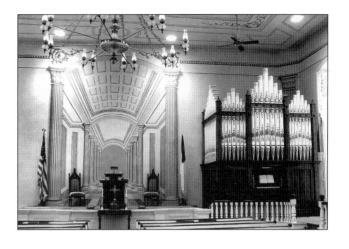

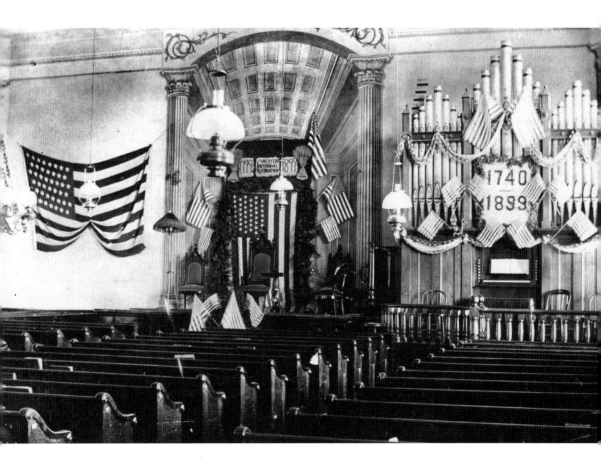

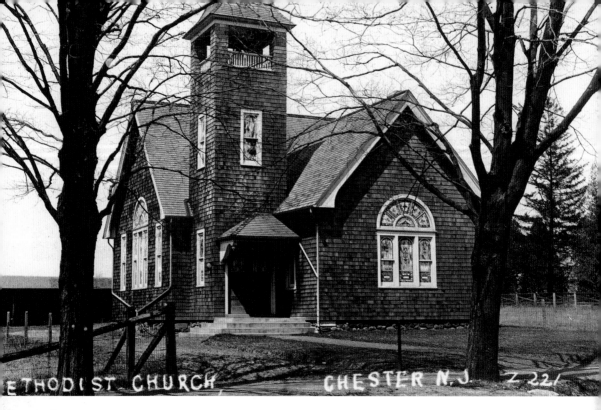

ETHODIST CHURCH, CHESTER N.J. Z 22/

This Methodist church was built along Main Street in 1908. A quotation from the Methodist conference describes it as "one of the most beautiful village churches in the whole Conference . . . with a bowled floor lecture room opening into the main audience room, cathedral glass windows of elaborate design, modern pews and a choir gallery." This building was used until it burned to the ground in 1921.

Benjamin McCourry and Nathan Cooper built this stone schoolhouse on September 15, 1830, at what has been referred to as the Crossroads. The building is believed to have been jointly owned, as the upper portion was used as a Congregational meetinghouse and the lower room was the schoolhouse. This was in the second school district, and Josephine Langdon was the teacher. Along Dover Chester Road, this old stone schoolhouse is now a private residence with a recent addition.

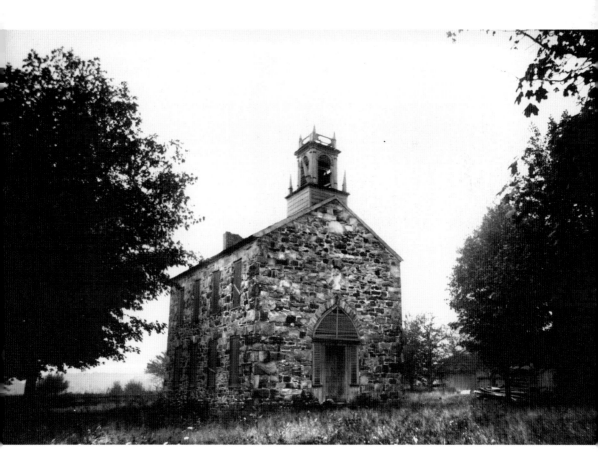

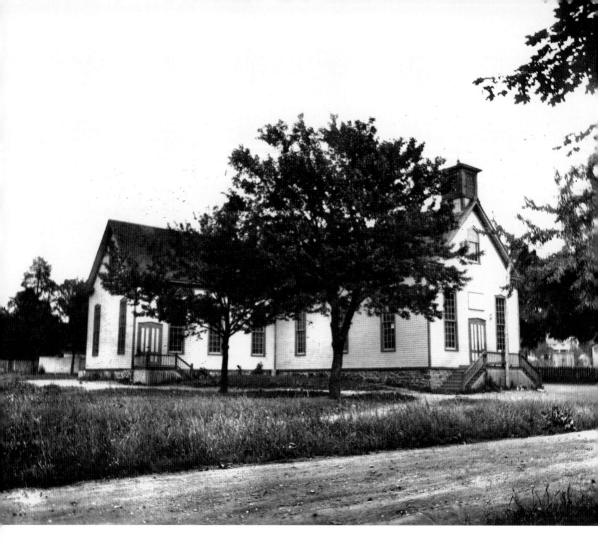

The first Chester School was moved to this location on Grove Street from Academy Lane and then added on to. When Williamson School was built on Main Street in 1924, this school was divided and made into four apartments. It was recently torn down to make way for an office building.

David L. Horton donated a piece of his land for a new Forest Hill School, which was originally built in 1866. This property, located in an area known as Hortontown, is along Dover Chester Road about one mile east of the center of town. This was the first school district, and Miss Paine was the teacher. It is now a duplex house.

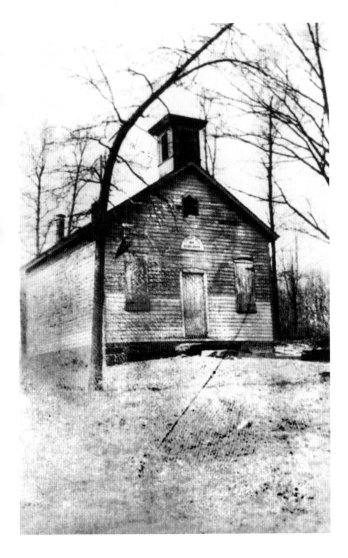

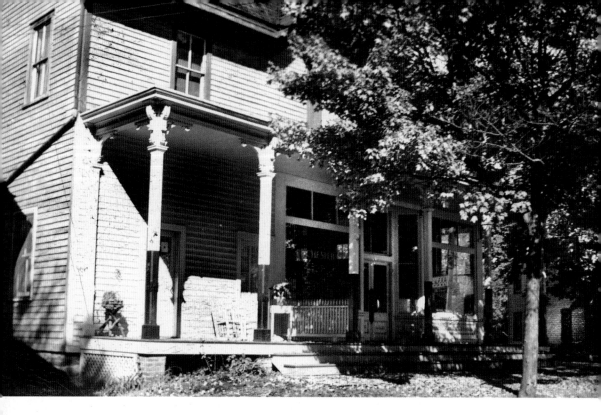

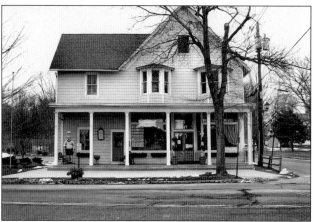

Pictured here, located at Hillside and Main, where the Hopler General Store was at one time, is the Chester post office. In 1966, Clyde Hopler celebrated 25 years as Chester's only rural delivery postman. During these years, 183 rural boxes for 250 families increased to 732 boxes for 850 families. Only twice did snow prevent him from delivering the mail. In those early days, Hopler delivered more than mail—often groceries—to an elderly couple on Parker Road. The building is now home to Bizzy Lizzy's and Once Upon a Table.

This class posed for a picture in front of the Pleasant Hill School before 1900. One schoolgirl was noted to have received a bible from S. White as an award for regular attendance at this Pleasant Hill Sabbath School. This school, located on Pleasant Hill Road, was also called the Woodhull District School and District School No. 5. This schoolhouse is now a private residence owned by the Pederson family. (Courtesy of Patricia and Henry Pedersen.)

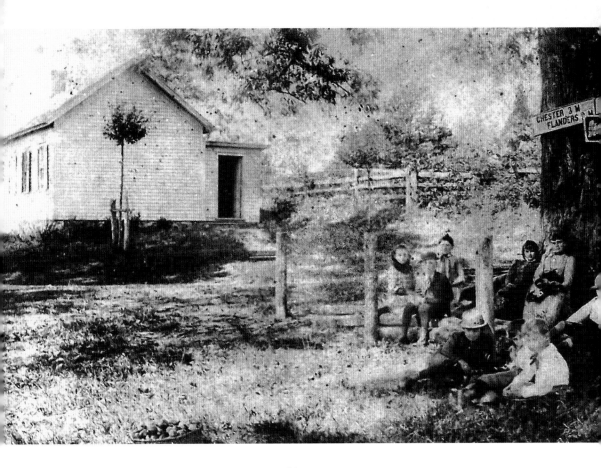

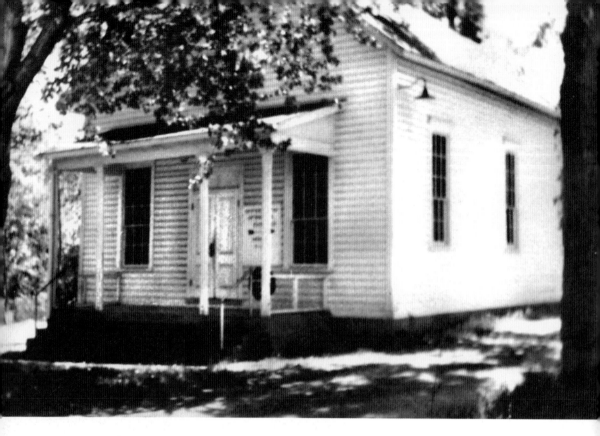

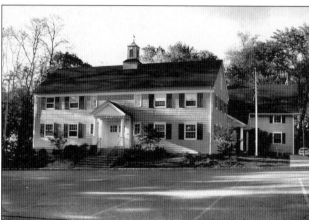

This building was once the school for children from Milltown and some from German Valley. The old Milltown School on Parker Road, now the township's municipal building, was so extensively remodeled in 1967 that the original structure is no longer recognizable. Prior to its purchase by the municipality in the 1930s, the old schoolhouse was owned by the Ku Klux Klan who used the building as a meeting hall.

During World War II, John Steinberg came up with the idea of a way to honor those serving their country. Steinberg, with a group of others, solicited funds and labor to erect a most attractive white colonial sign with the names of 110 men and women in the service from the borough and the township. At a very emotional ceremony, the honor roll was dedicated and unveiled by Mrs. Austin Thompson and Mrs. Joseph Bragg. This honor roll was later replaced by the memorial stone pictured on the next page.

*Chapter 5*

# PEOPLE AND PLACES

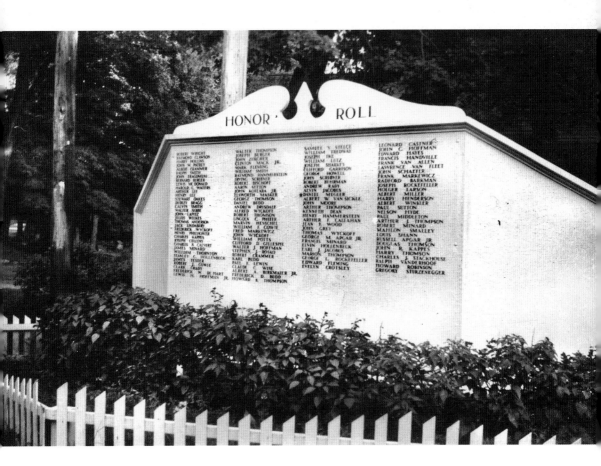

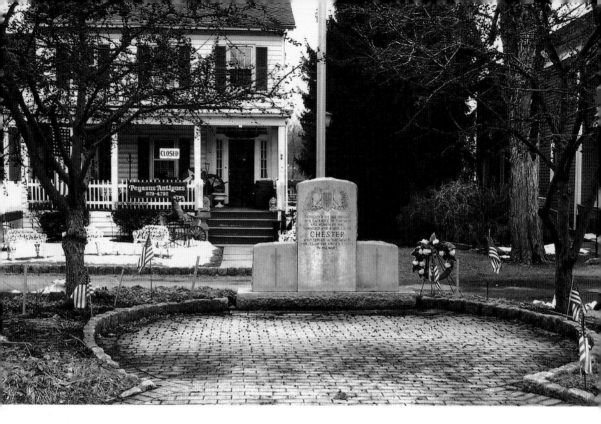

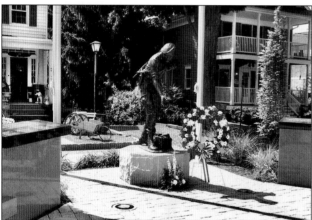

Larry Maysey lived in Chester all of his young life, and he was a friend, companion, and role model to many. When his nation needed him, he was there, not only enlisting for service in Vietnam, but also volunteering for training in the most difficult of assignments. Maysey became a member of the elite para-rescue unit, and by October 1967, Sergeant Maysey, rescue specialist, was flying missions all over southeast Asia. On November 9, 1967, he was killed as his helicopter crashed to the ground. Maysey was awarded the highest honor the U.S. Air Force conveys. On Memorial Day, 2005, the Larry Maysey Veteran's Memorial was dedicated along Main Street, not only to Maysey's memory, but to all those from Chester who have died in war.

Fondly known as the twins, John and Willard Apgar were born on January 6, 1927, and came from a family with long-time roots in the area. Pictured here on the corner of Hillside and Furnace Roads in the late 1930s, the Apgar boys stand in front of the site where the trap shooting building used to be. That building was moved to Route 206, and Earl Jacobus and his wife built their home here.

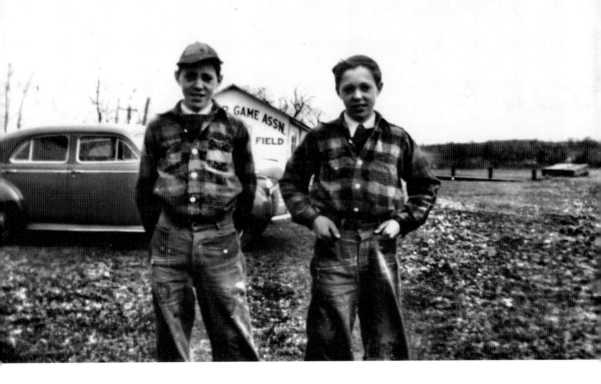

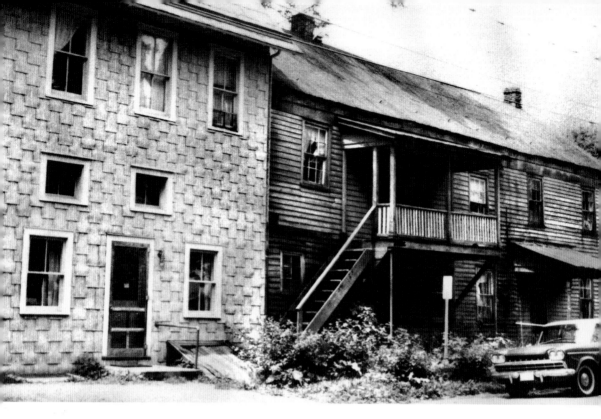

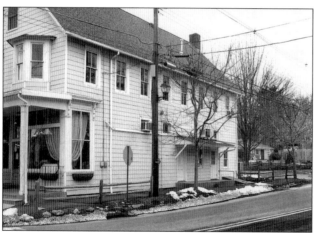

Pictured here is Chester's first old tavern building at Hillside and Main Streets. The date that Isaiah Fairclo turned the old tavern into a store was perhaps as early as 1802 when the tavern across Main Street was built. This original tavern also was Chester's first general store. It had been moved back on the property in the 1880s, and the newer section was added on for a mining company store by Cooper-Hewitt and Company.

This farm at the southwest corner of Route 513 and Parker Road was bought by Alfred W. Hinds from Obadiah Howell and was the site where he operated his cider mill and distillery. It was purchased and the barns were renovated by the Church of the Messiah, which is the Episcopal church for Chester, Chester Township, and Long Valley. This church is a part of the Anglican communion and the Episcopal church and is a parish in the diocese of Newark.

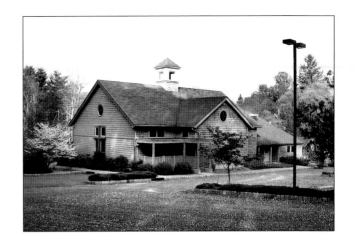

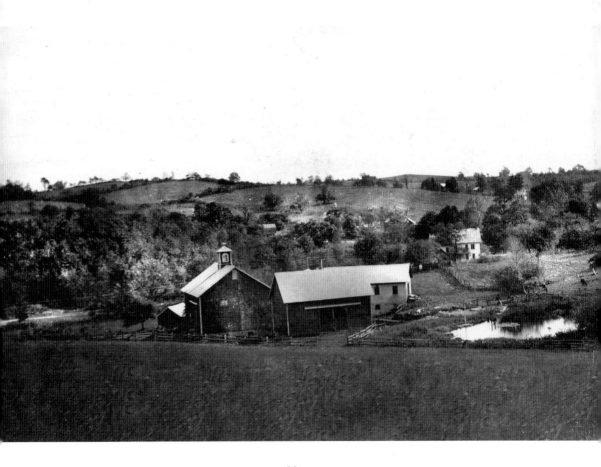

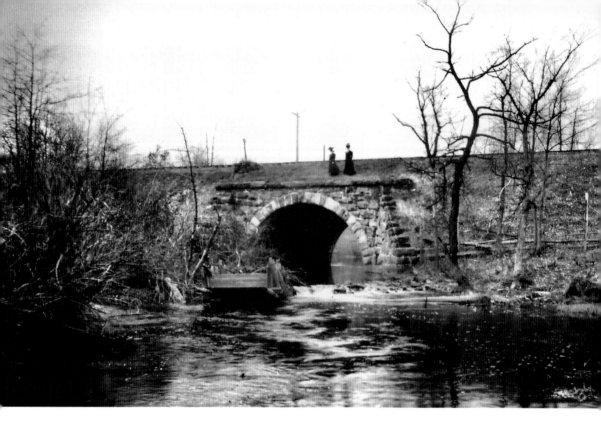

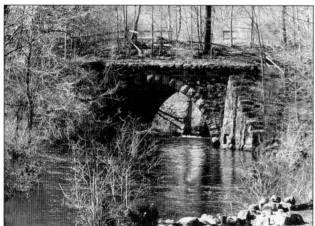

On July 18, 1872, the High Bridge Railroad filed a map of its route from High Bridge to the Chester Railroad. Pictured here is the bridge over the Black River, which was very close to where the Chester branch of the Central Railroad met up with the Delaware, Lackawanna and Western Railroad. Even while there was a track connection between the Central Railroad of New Jersey and the Lackawanna, no passenger service was run, and there was no effort to facilitate connections between the two railroads. The Chester Hill branch connected just east of the railroad's bridge over the Black River and extended to the Hedges mine.

This was the former Chester borough municipal building that was sold at auction on September 20, 1965. High bidder at the auction, the Chester Theatre Group became the new owner of this hall located at the intersection of Grove Street and Maple Avenue. The next year was spent restoring the building and converting it into a theatre in the round, with the stage in the center surrounded by the audience sitting on raised platforms. The group, founded in 1959, originally held their productions at the Williamson School on Main Street. They eventually named the building the Black River Playhouse. Some of the uses for the building had been a school, a warehouse, a garage, a repair shop, and a meeting hall.

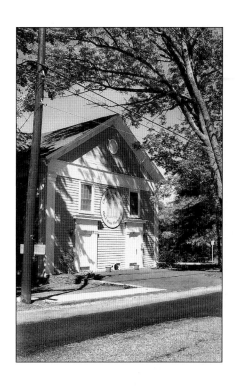

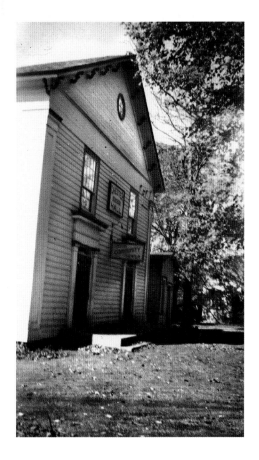

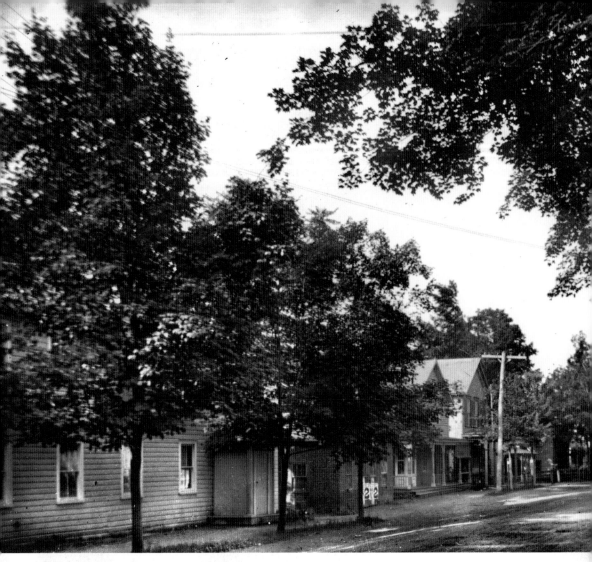

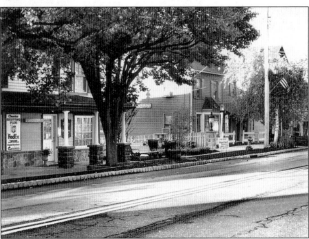

Thomas A. Moore, a Civil War veteran, resided in a house on the corner of Budd Avenue and Cherry Street. Pictured here along Main Street is where he worked hard repairing and painting wagons. His shop was two doors west of Warren Street. The shop is no longer there, but much of the look of Chester's Main Street remains the same as it did back then.

The Chester Volunteer Fire Company held its first official meeting in October 1921, and the members built this firehouse in 1923. By 1940, this is what the firehouse looked like. In 1950, the north side addition was put on, and in 1962, the south side was added.

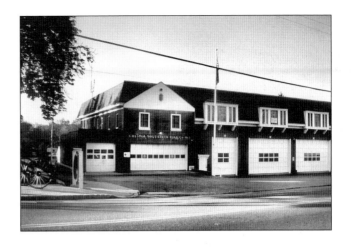

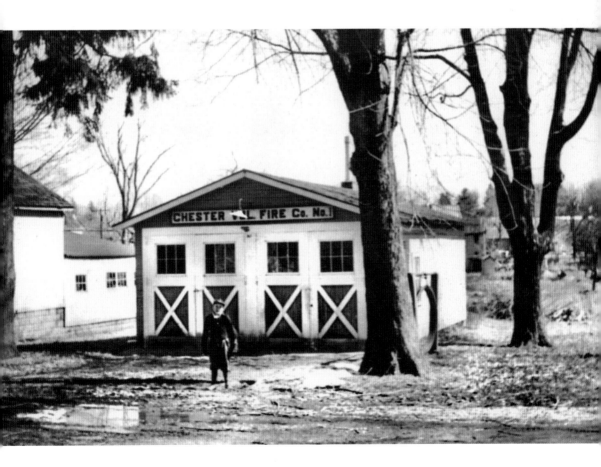

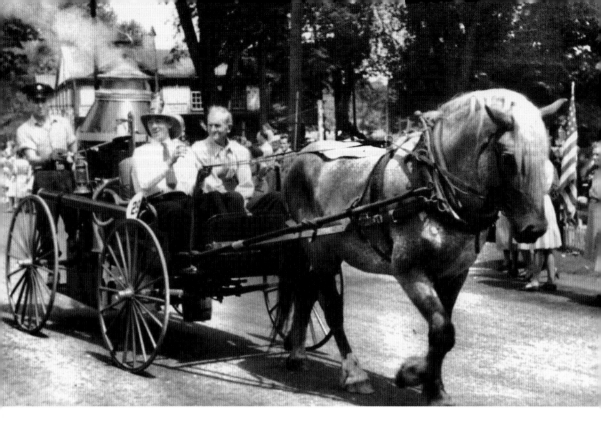

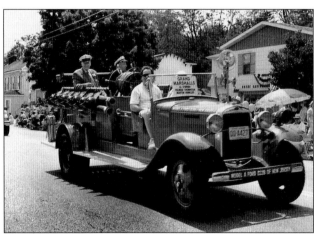

This older photograph shows the 1947 Fourth of July parade. The parade was a yearly event for Chester. Pictured in the old-time fire truck are, from left to right, Jack Hoffman, Reuben Thompson, and Austin Thompson. The newer version was taken at Chester's bicentennial celebration in 1999. Sitting atop the old fire truck is Al O'Brien (left) and Reuben Thompson. Born on August 12, 1912, Reuben Thompson has served on the Chester Volunteer Fire Company for over 70 years.

The Weldon Brothers came to this area from England around 1739. They were mining men with magnetic compasses whose needles fluctuated madly, telling them that under the rocks in this area was a strain of iron ore. Later, during the mining days in Chester, there were three mines on Mine Hill located on State Park Road, one of which was the location of a tragic accident called the hanging wall disaster. Six men were buried under thousands of tons of rock and dirt when the wall gave way during mining. This Hacklebarney trestle and roaster were used with the mines to carry ore down from the upper mines. It was dumped directly into the roaster through an opening in the top. Roasting was necessary before the iron was usable. No traces remain of this

testament to Chester's glorious past because an early morning fire on June 13, 1885, destroyed the trestle and wooden enclosures.

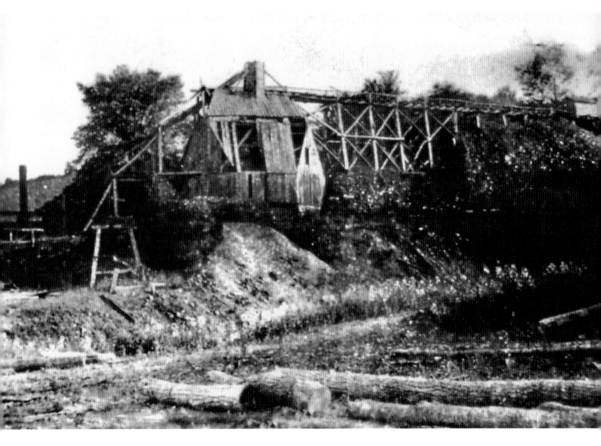

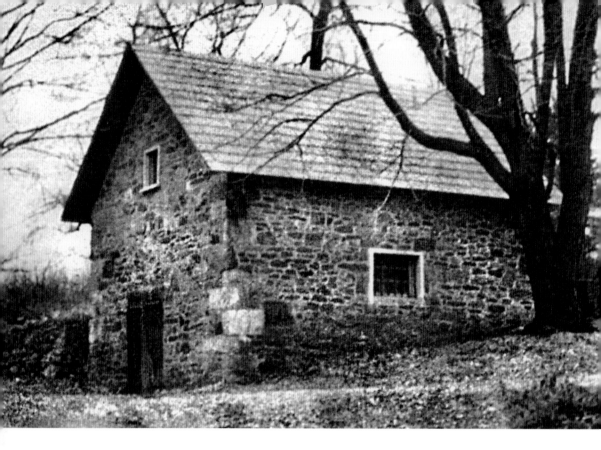

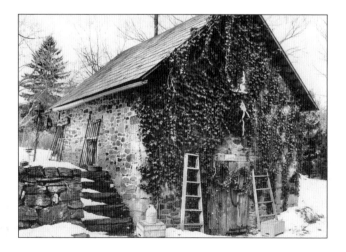

Chester has always been known for its apple and peach crops, and there were many distilleries throughout the town that produced Jersey Lighting applejack. Long-time Chester historian Edwin Collis once noted that the area "was one great apple orchard all the way from Dover to Chester." The farm at the corner of Route 24 and Parker Road was purchased by Alfred Hinds from Obadiah Howell to build a cider mill, distillery, and Lincoln house. Pictured here is the Lincoln house, which was a small stone building with iron-barred windows, where Bonded Brandy was kept under lock and key during the period of aging. In 1882, Richard Stephens purchased the farm and continued to operate the distillery until around 1890 when he leased it to the N. J. Sharp Company, who named it Mountain Spring Distillery. Pictured in the contemporary photograph is the building as a potting shed and one of the jugs that had originally held applejack.